momentsHATSnationalge... m
TSnationalgeographicmo...HATSna
eographicmomentsHATSnationalgeogr
omentsHATSnationalgeographicmome
TSnationalgeographicmomentsHATSna
eographicmomentsHATSnationalgeogr
omentsHATSnationalgeographicmome
TSnationalgeographicmomentsHATSna
eographicmomentsHATSnationalgeogr
omentsHATSnationalgeographicmome
TSnationalgeographicmomentsHATSna
eographicmomentsHATSnationalgeogr
omentsHATSnationalgeographicmome
TSnationalgeographicmomentsHATSna
eographicmomentsHATSnationalgeogr
omentsHATSnationalgeographicmome
TSnationalgeographicmomentsHATSna
eographicmomentsHATSnationalgeogr

national geographic *moments*

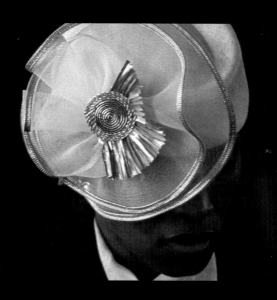

HATS

by K. M. Kostyal

NATIONAL GEOGRAPHIC

Washington, D. C.

"If I don't wear a hat, things don't happen to me. So I wear one every-day," says millinery designer Shirley Hex. There is just something about hats, and always has been since ancient Egyptian royalty began sport-ing elaborate headgear 4,000 years ago. Throughout history, hats have signaled to the world all kinds of things about their wearers—personal style (conservative or outré?), mood (playful or serious?), morals (white hats for the good guys, black for the bad), even status in the world (king, commoner, or warrior chief). ❧ And of course hats have

Hats

provided great fodder for photographs. The Berber bride whose eyes search yours from a narrow slit in her elabo-rate head scarf would probably have lost much of her mystery were she photographed simply as a bareheaded girl. The Papua New Guinea man bedecked in a crown of feathers and flowers that would put Parisian haute couture to shame sticks in the mind's eye for-ever. And the two Flemish matrons, their close-fitting bonnets bent together as they share a quiet moment, speak to a time now gone. ❧ But hats have been part of the human experience far longer than cam-eras have been around to record them. As far back as Greek and

Roman times, the conical Phrygian cap was reserved only for freemen; a slave was reduced to the indignity of bareheadedness. Yet, in many of the early cultures, and in many cultures still today, modesty—often bolstered by deep spiritual conviction—required that women cover their hair and shoulders with a loose scarf or veil. ❧ In Europe modesty gradually gave way to fashion, and by the 15th century, many noblewomen proudly sported the bizarrely shaped *hennin,* which rose to a soft point a full foot above their heads. At about this time, the most coveted hats were the fine straw ones from Milan, and haberdashers throughout Europe imported them, becoming known as *Millaners,* and later milliners. Throughout the centuries to come, they would do a brisk business, as hat styles changed, and changed, and changed again. ❧ So, naturally, did hairstyles, and the two—hat styles and hairstyles— have always had a lot to do with each other. During the extravagant days of the late 18th century, when noblemen favored the long corkscrew-curl tresses of wired wigs, hats lost out to hair as the supreme fashion statement. There simply was no room among the curls to accommodate a hat. ❧ Yet style is only one part of the hat story.

Status, politics, and power also figure into the history of the hat. During the Italian Renaissance, each of the great families had its own particularly colored and shaped hat, and wearing it was like bearing forth under the family seal. ⌖ Occasionally, hats have even been implicated in altering the course of history—or at least being party to great historical moments. Think of the tricorne, or three-cornered hat, so closely identified with America's colonial revolution. Or the military hats that have launched armies forward, part of the glue that binds men into a single, fighting body—a symbol of pride and belonging. ⌖ And hats have played their roles in powerful historical moments. When England's Charles I mounted the scaffold in 1649, the deposed king proudly wore his wide-brimmed Cavalier "chimney pot." Not only did Charles lose his head, but the appeal of the chimney pot died almost instantly and stayed dead for generations to come. ⌖ Charles's cavalier gesture did nothing, though, to deter the European taste for the hat's fabric—beaver. For three centuries, beginning as far back as the 1550s, hats made of beaver pelt were the rage in Europe, and the top hat variety much the preferred shape. Legend has it that the first silk top hat

appeared in Paris in the late 18th century. By the end of the century, a London hatter, John Hetherington, had brought it to English attention by wearing a tall, shiny version of it, created by applying silk shag to the beaver-felt base. At first Hetherington's hat was met with great public derision. But derision soon turned to desire, and European gentlemen began a century-long love affair with the top hat. ❧ The "silk" that gave it its gloss was really cured beaver pelt, and so great did the demand for these faux silk hats become that by the early 1800s, the poor rodent whose fur gave the fashion its shine had been hunted to extinction on the continent. But the beaver riches of North America lay largely untapped, and intrepid trappers and traders set out into the uncharted West for pelts. By the mid-19th century, the American beaver too had been almost eradicated, and the mountain men were left with nothing to do but chart the West and help open it to floods of newcomers. ❧ Not only did the beaver top hat play a large part in America's Manifest Destiny, it also gave rise to a character that found an inspired place in literature: the "mad hatter." A tragicomic figure, he was the hatmaker whose constant exposure to mercury, used to turn beaver pelts into

the glossy felt coveted in the top hat, left him with neurological damage, impairing his memory and his movements and often making him a misunderstood figure of public derision. ✎ By the early 20th century, hat styles were changing as quickly as other couture, thanks in part to the advent of photography. Styles spread, influenced one another, morphed into something new. And National Geographic photographers were there to capture the never-ending human cupidity for headdress—from the Russian man's de rigueur *shapka* to the African family in their straw boaters to the Bolivian Indians in their somber black bowlers. ✎ When, in the 1920s, Kemal Ataturk banned the fez in his race to Westernize Turkey, the Geographic was there as Turkish men turned to caps instead. When the cowboys of today prop their Stetsons at just the right angle, to let the world know cowboys are still alive and well, Geographic photographer Bill Allard is on hand to record the gesture. ✎ Cowboy hats have never lost their appeal in the American West, not since John Batterson Stetson popularized them in the mid-1800s. But hat wearing in general faced a serious demise in much of the industrialized world in the late 20th century, as decorum gave way to

casualness. For a while, it seemed the hat, as a fashion statement, would go the way of spats. ⟶ But no. In a grand, take-all-comers comeback, the baseball cap became a craze for men, women, and kids. Put one on, and you signaled the world that you'd slipped into a certain mood. Put it on backward, and the signal got stronger. ⟶ Hats, after all, have always had that effect. In all of these pictures, no matter the time or place they were taken, the message seems to be the same: Put on a hat before you face the world, and things will just go better. ⟶

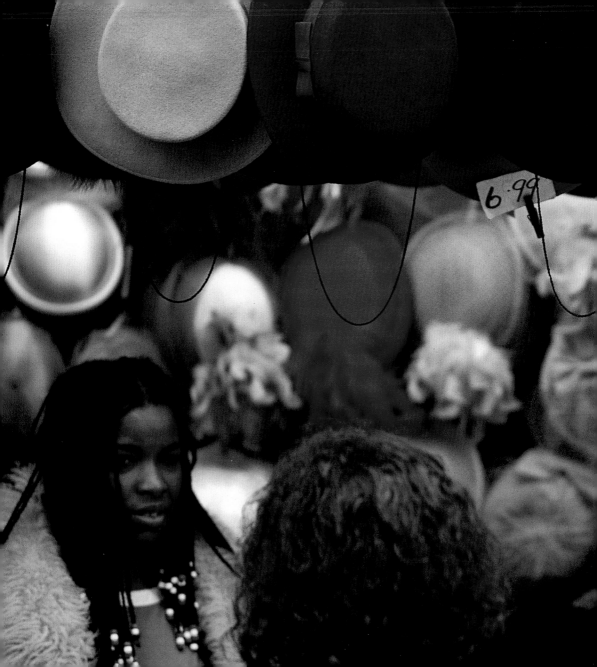

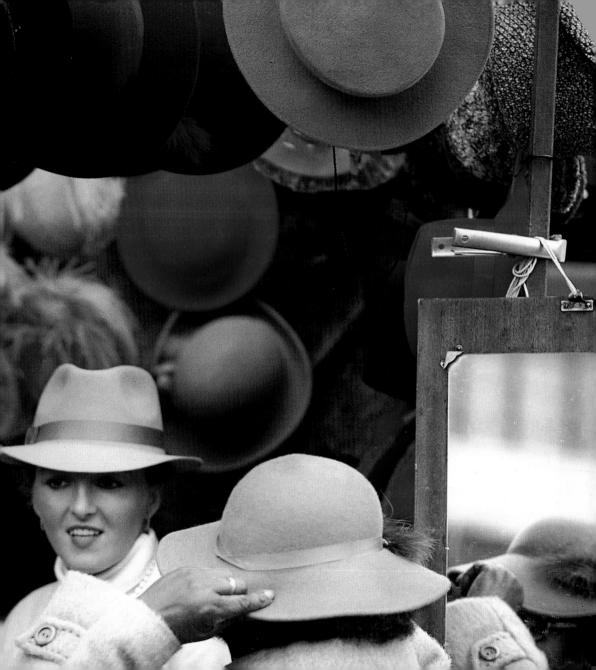

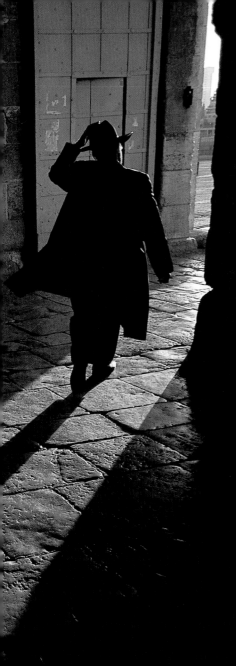

MIDDLE EAST, EXACT
LOCATION UNKNOWN
2001
REZA

preceding pages
LONDON, ENGLAND
DATE UNKNOWN
JODI COBB

CHICAGO, ILLINOIS
1926
ACME NEWSPICTURES

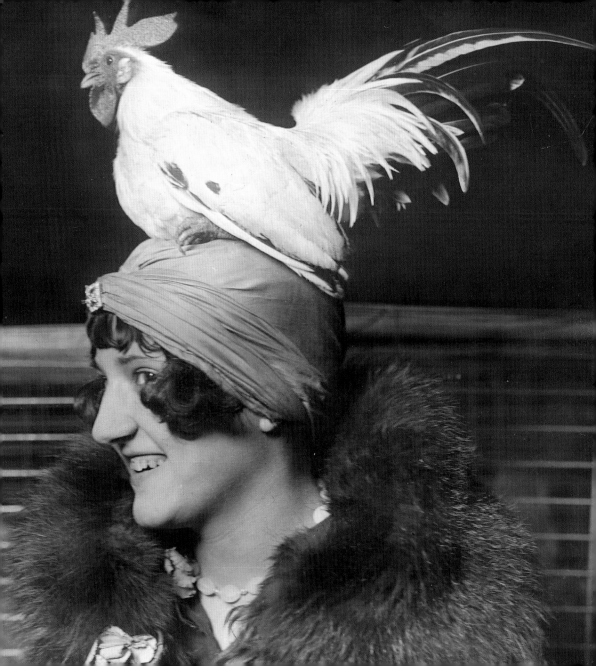

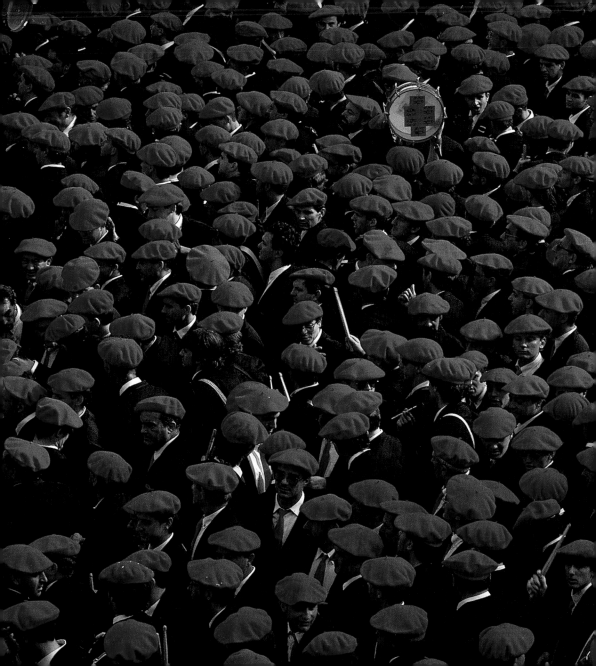

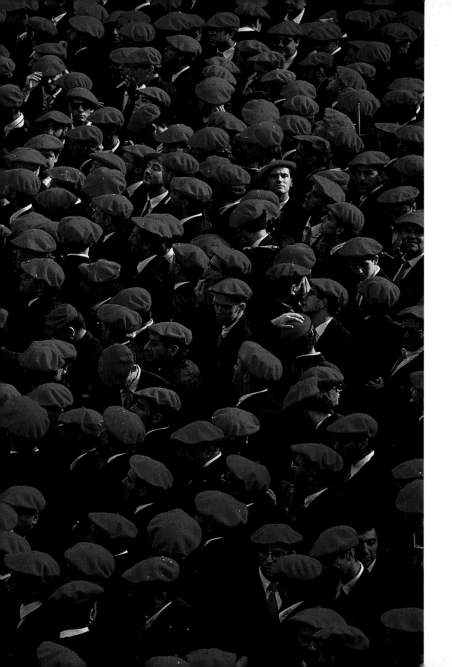

IRUN, SPAIN
1995
JOANNA B. PINNEO

following pages
MARSEILLES, FRANCE
1944
W. ROBERT MOORE

PONT L'ABB´E, FRANCE
1938
FRANCIS C. FUERST

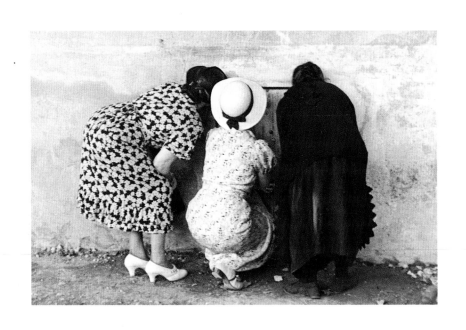

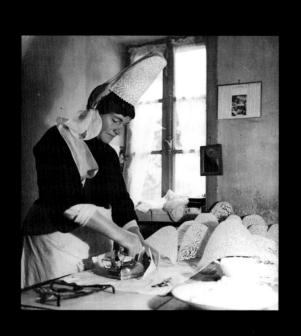

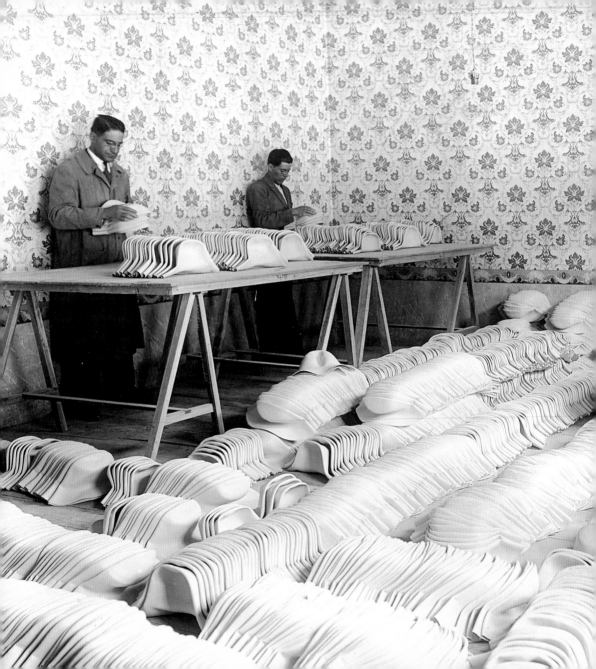

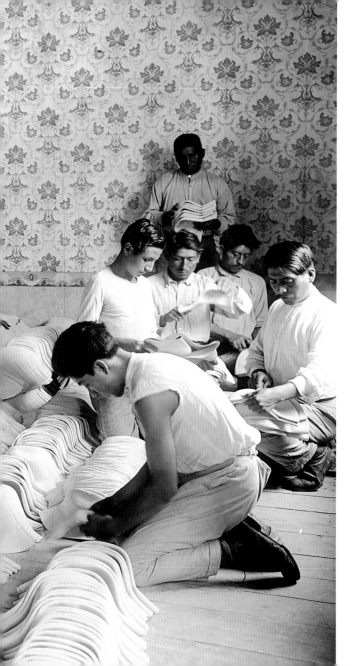

ECUADOR
1939
PHOTO FROM
STANLEY BRANDON

following pages
**BLACKPOOL,
LANCASHIRE, ENGLAND**
1998
TOMASZ TOMASZEWSKI

KOREA
1917
NORMAN THOMAS AND
W. W. ROCK

TURKISTAN
1927
PHOTO FROM
HOOKER A. DOOLITTLE

PARTRIDGE, KANSAS
1990
JOEL SARTORE

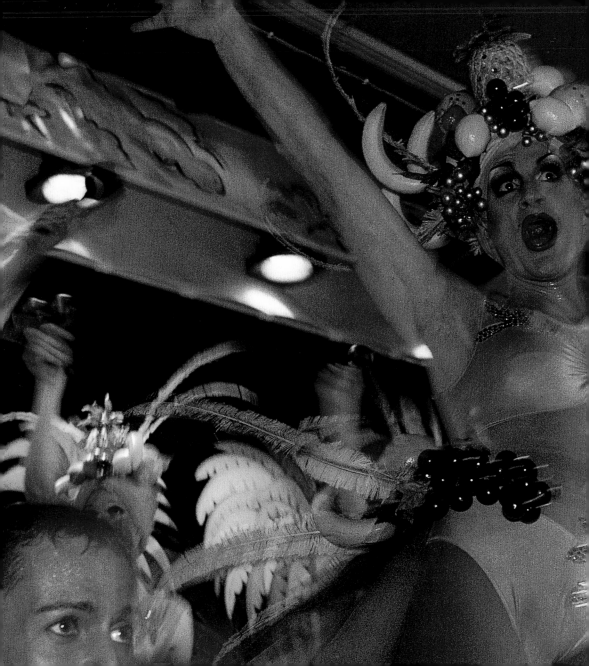

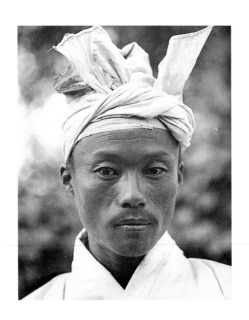

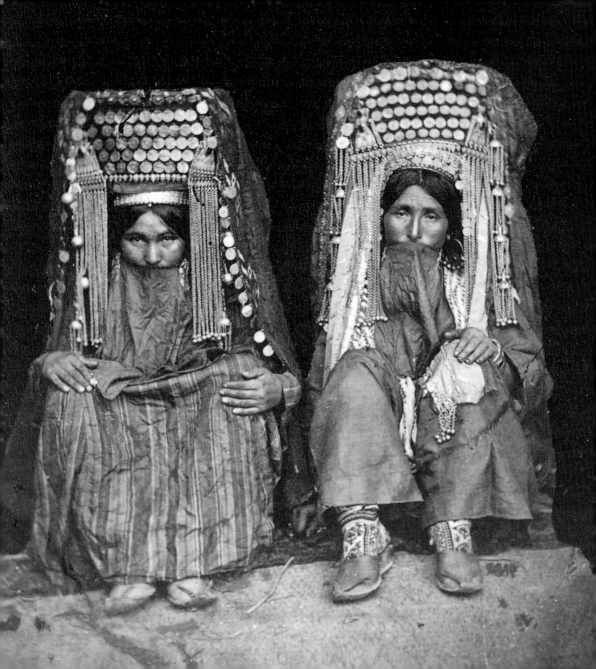

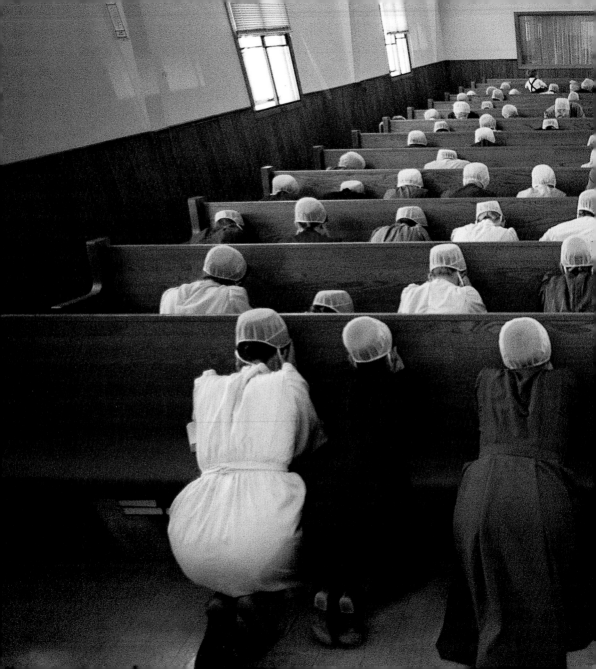

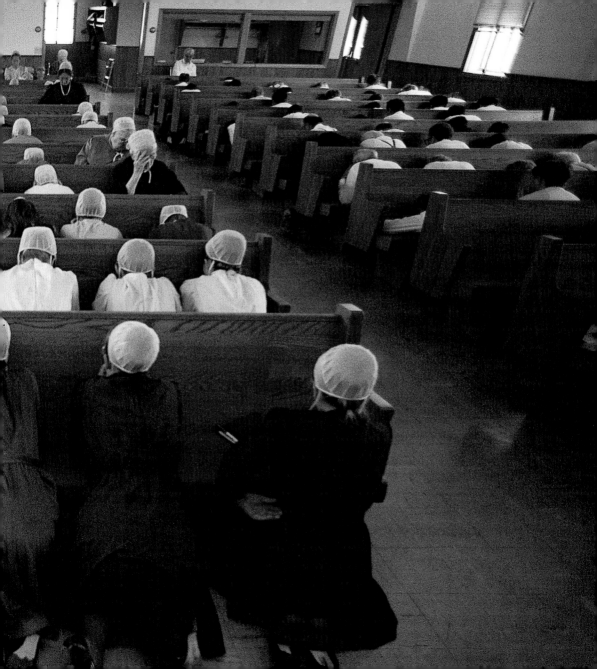

If the clothes make the man, a

he saying goes, it's his hat that says it all. Fifty years ago, no respectable middle-class man in America would have left home without his fedora, but the angle at which he wore it, ah, that said it all. Though that formality isn't observed these days, hats are still a badge of identity: They tell the world at a glance that a man's an Orthodox Jew, or a drill sergeant, or a golfer, or a Cubs fan. ⚬

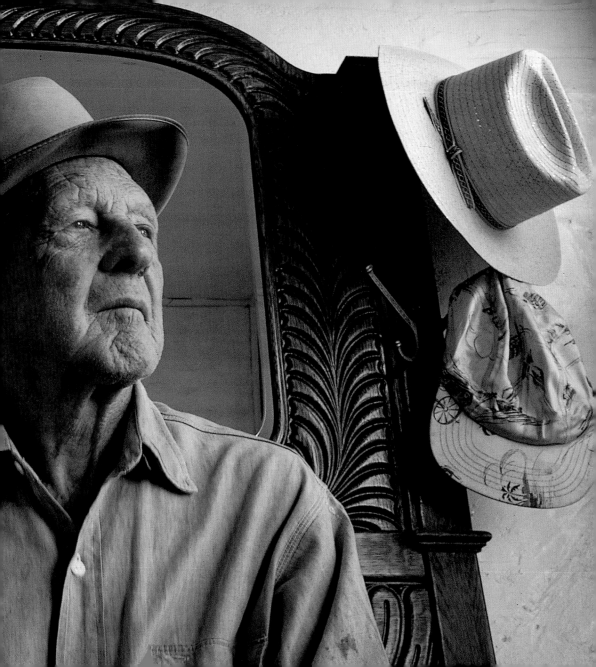

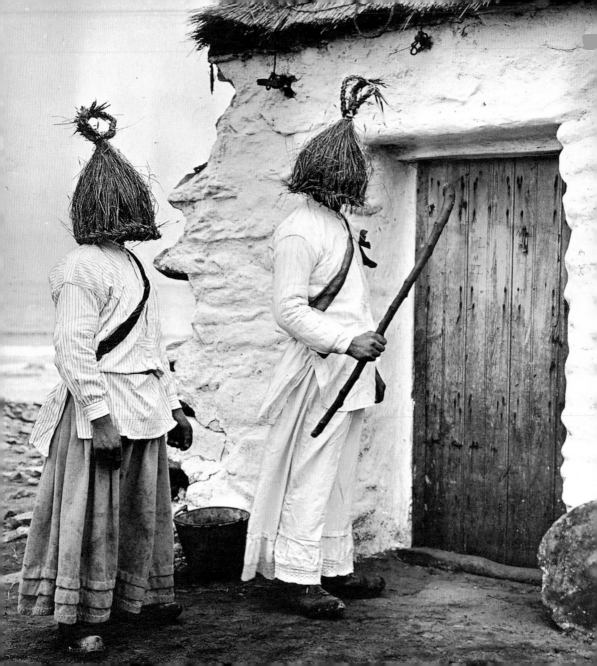

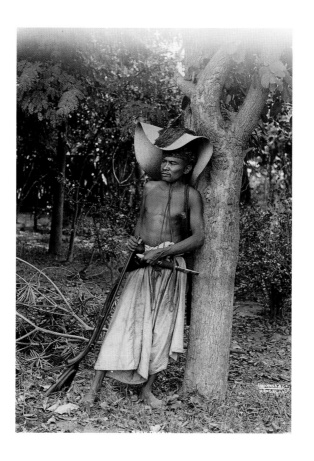

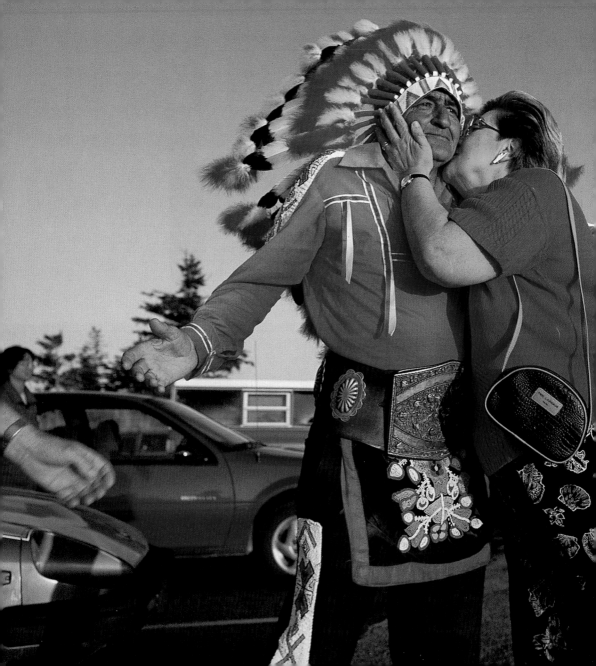

CHEROKEE, TENNESSEE
1995
MAGGIE STEBER

preceding pages
AUSTIN, NEVADA
1971
SAM ABELL

ACHILL ISLAND, IRELAND
1927
A. W. CUTLER

BURMA
1921
JOHANNES & CO.

following pages
LOCATION UNKNOWN
1970
HOWARD SOCHUREK

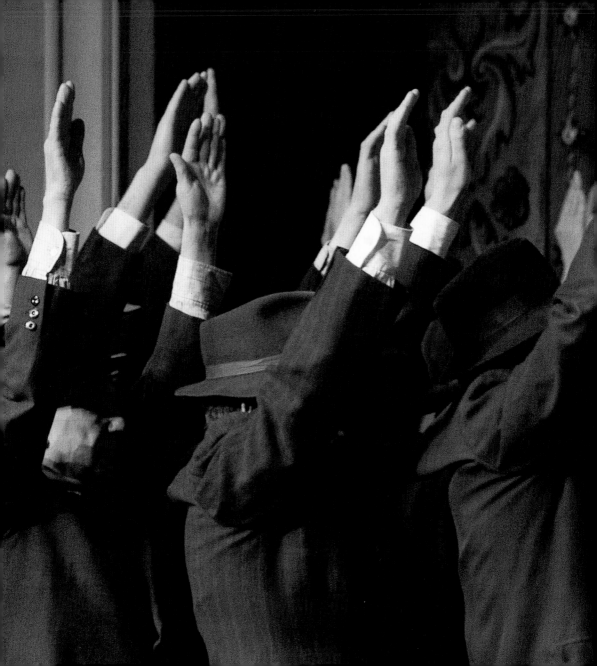

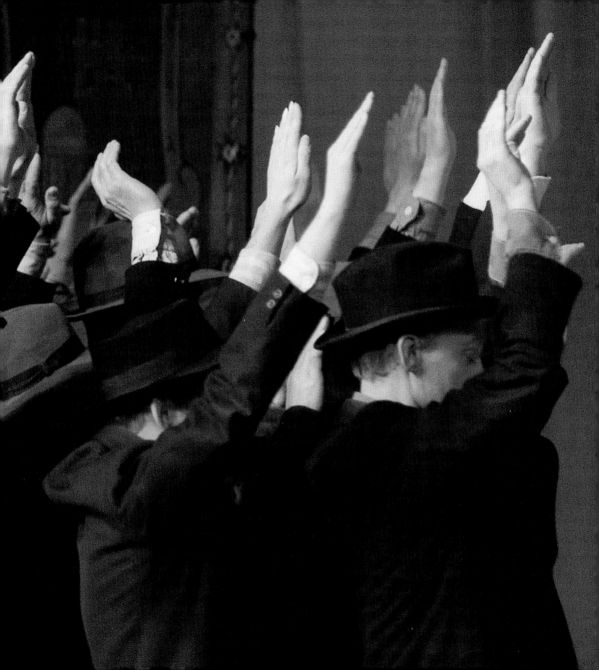

WHIDBEY ISLAND,
WASHINGTON
1995
RICHARD OLSENIUS

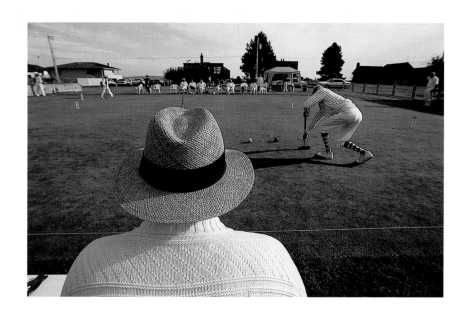

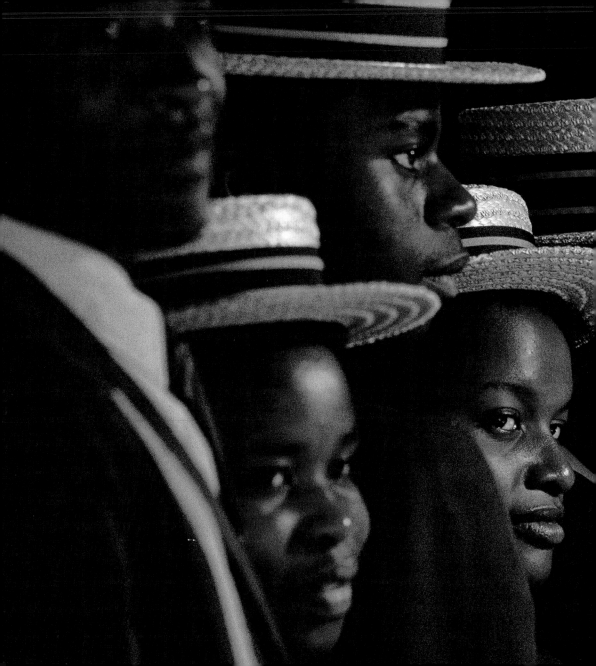

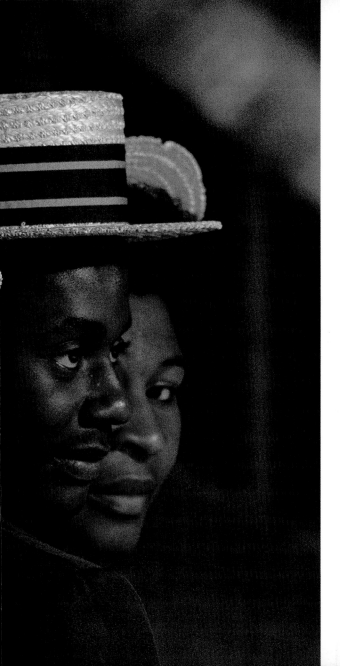

MALAWI
1989
ELI REED

following pages
**NEW ORLEANS,
LOUISIANA**
1992
JOEL SARTORE

JAPAN
1911
WILLIAM WISNER CHAPIN

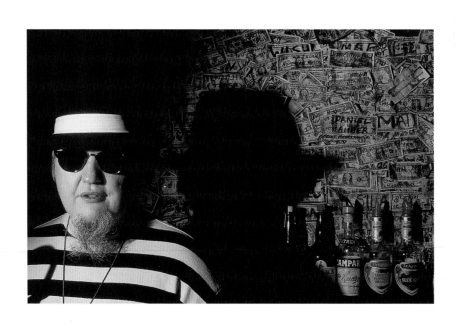

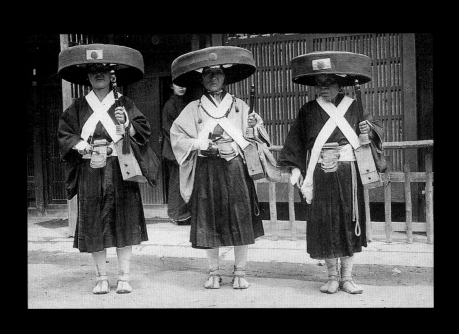

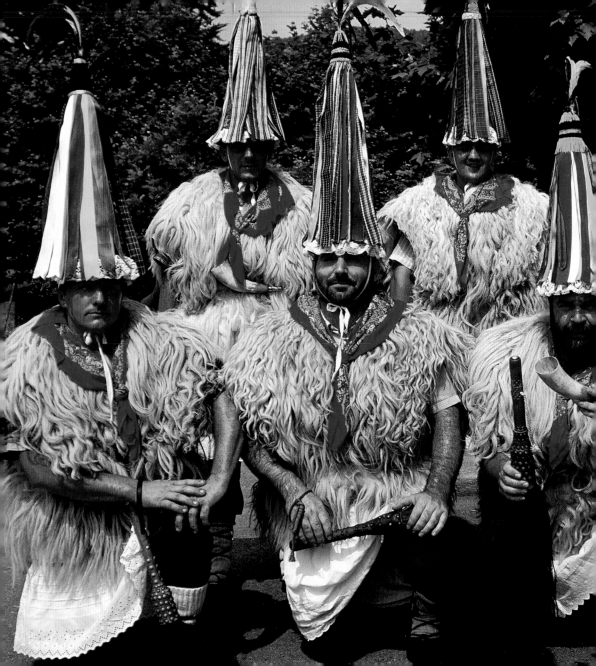

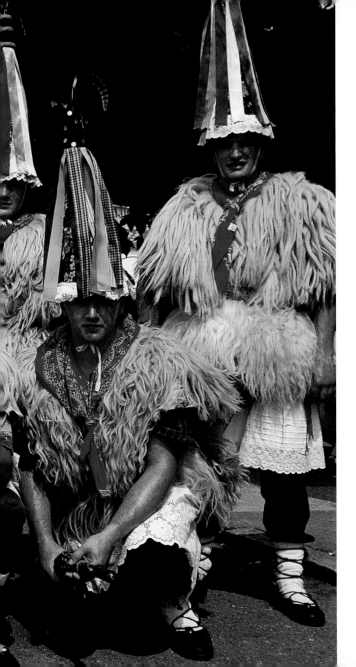

ITUREN, SPAIN
1995
JOANNA B. PINNEO

following pages
HOLLAND
1916
FRANKLIN PRICE
KNOTT

LOCATION UNKNOWN
DATE UNKNOWN
HENRY ROWEN LEMLY

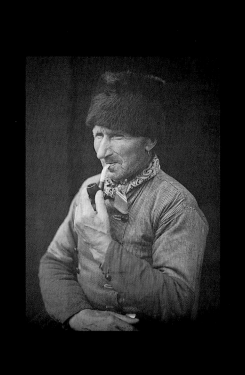

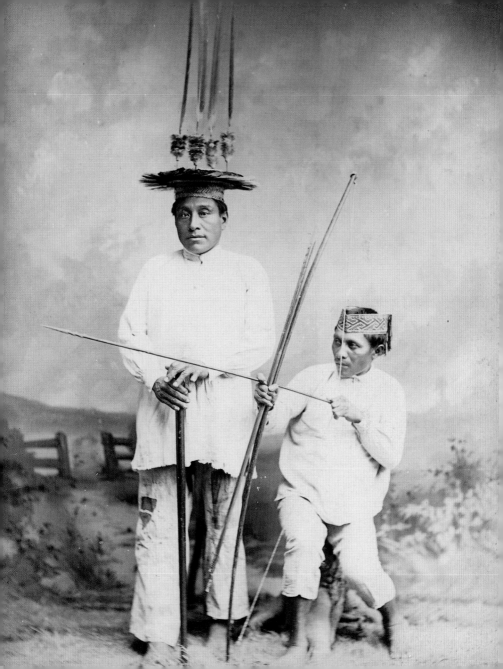

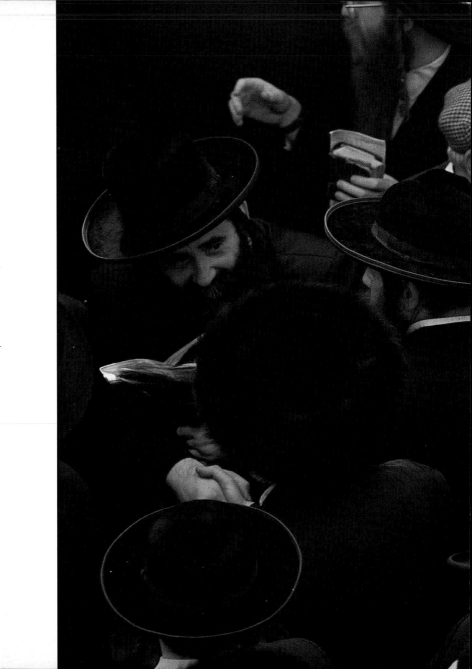

GALILEE, ISRAEL
1995
ANNIE GRIFFITHS BELT

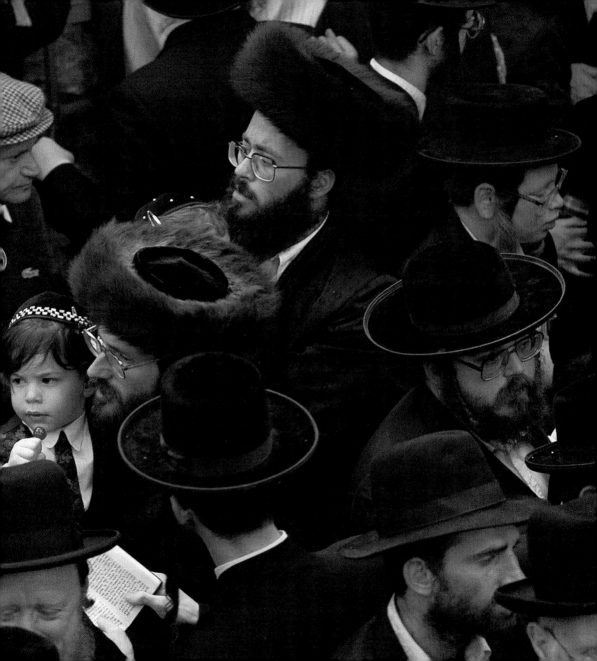

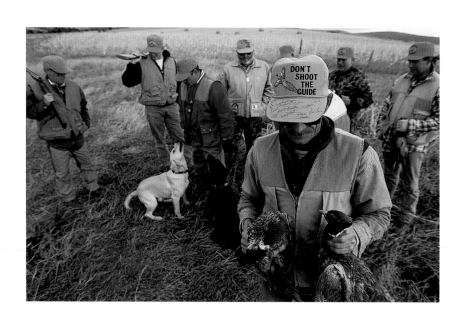

BROKEN BOW,
NEBRASKA
1996
JOEL SARTORE

following pages
NEWFOUNDLAND
1971
SAM ABELL

PENSACOLA,
FLORIDA
1991
JOEL SARTORE

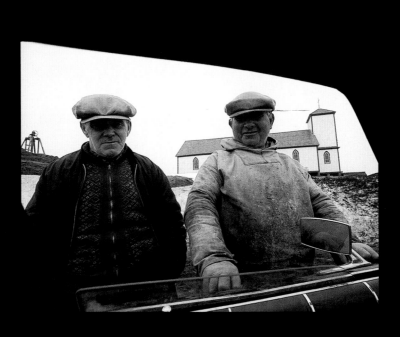

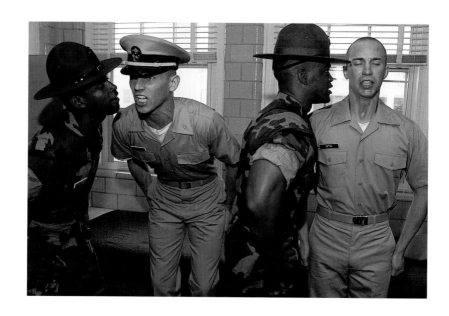

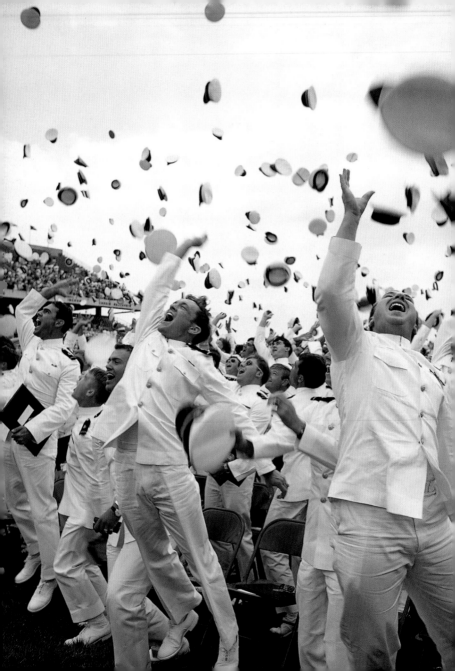

ANNAPOLIS, MARYLAND
1972
ROBERT W. MADDEN

What started out as a head covering

obligatory for female modesty, long ago turned into a irrepressible statement of personal style. Hats have ranged from simple bonnets to dramatic, head-hugging cloches to feathered, laced, and winged extravaganzas. Hats and photographs of them—the elaborate wimple-like head coverings of Dutch women attending a church service, or the horned headgear of Mongolian wives—have a nostalgic power to evoke times and places now lost to history. ❧

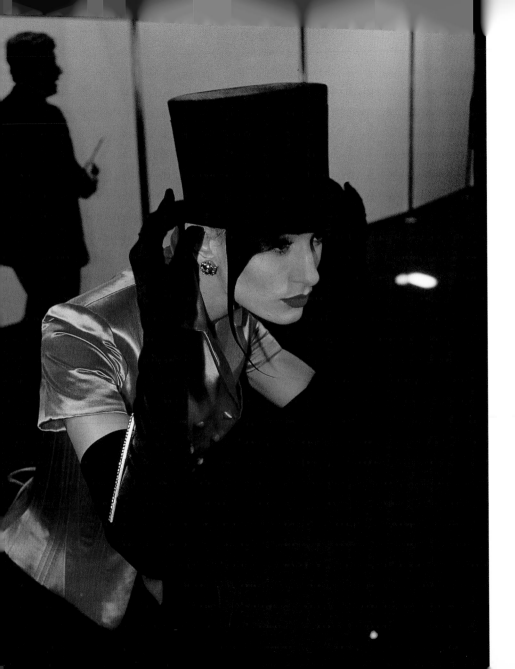

PARIS, FRANCE
1989
WILLIAM ALBERT ALLARD

following pages
ZEALAND, THE NETHERLANDS
1929
DONALD MCLEISH

MEXICO
1916
PHOTO FROM G. M. KERR

BELGIUM
1925
GEVAERT PHOTO
PRODUCTION COMPANY

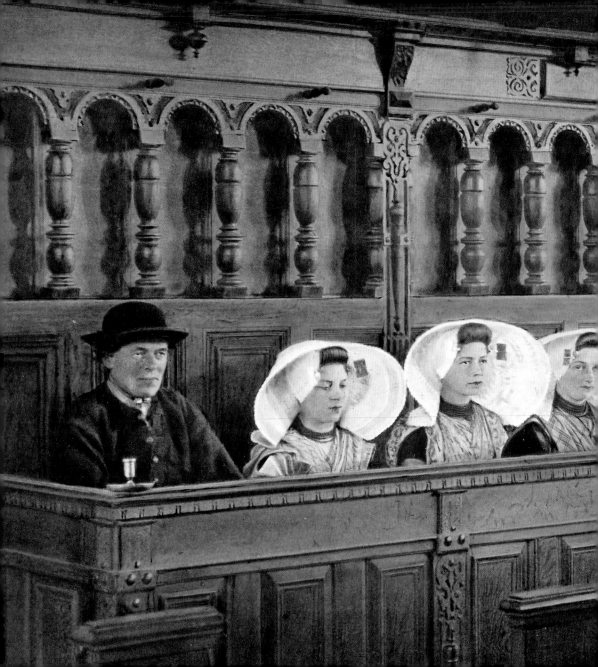

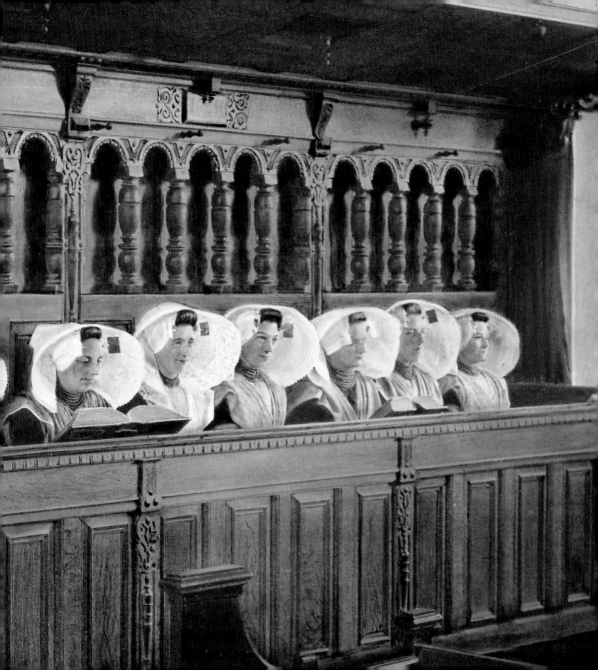

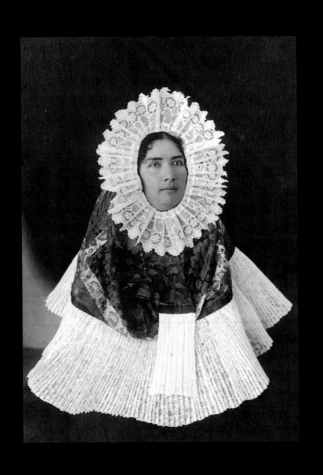

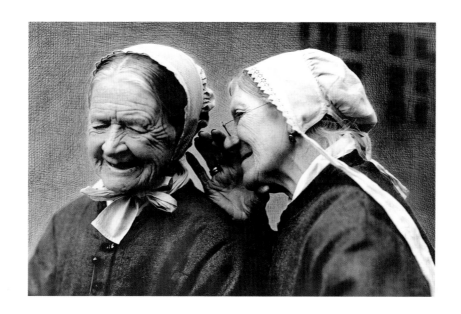

MONGOLIA
1921
PHOTO FROM
HORACE BRODZKY

following pages
ALSACE
1927
GERVAIS COURTELLEMONT

BLACK FOREST, GERMANY
1928
HANS HILDENBRAND

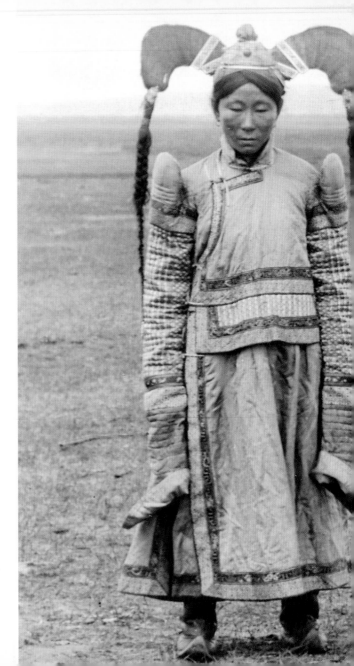

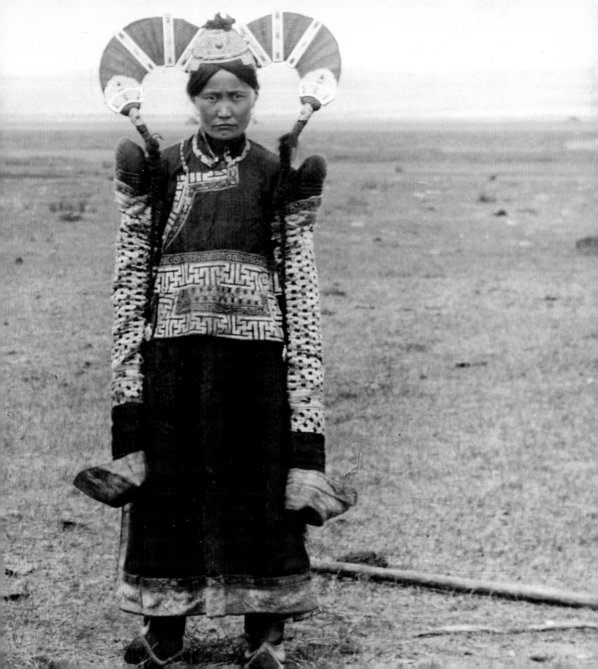

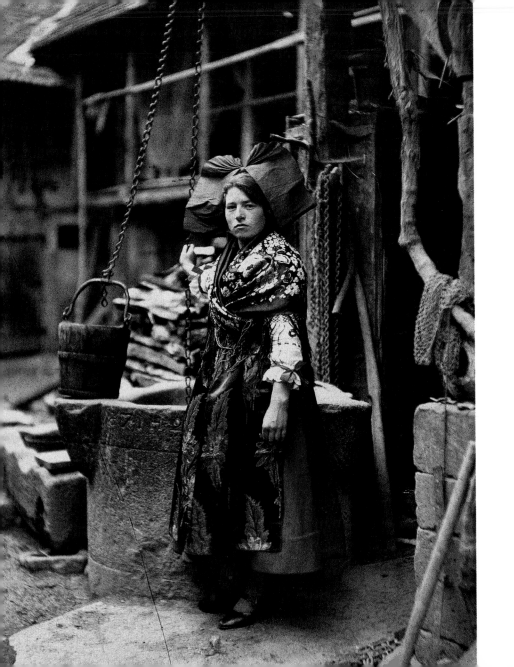

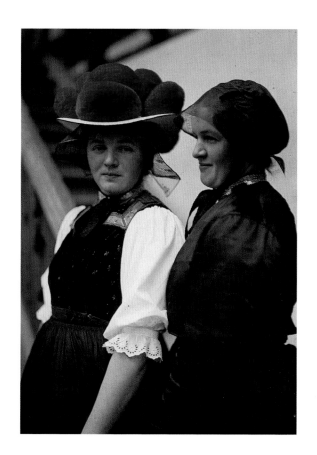

BLUNDEN HARBOR,
BRITISH COLUMBIA,
CANADA
DATE UNKNOWN
EDWARD S. CURTIS

folloiwing pages
PERU
1977
BATES LITTLEHALES

EL PASO, TEXAS
1996
JOEL SARTORE

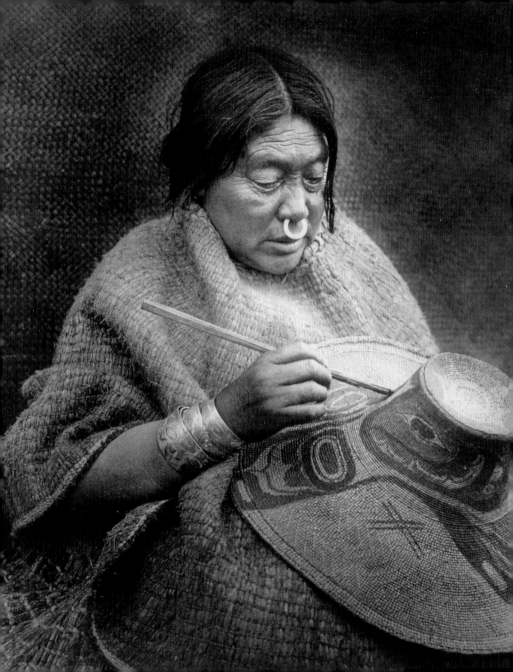

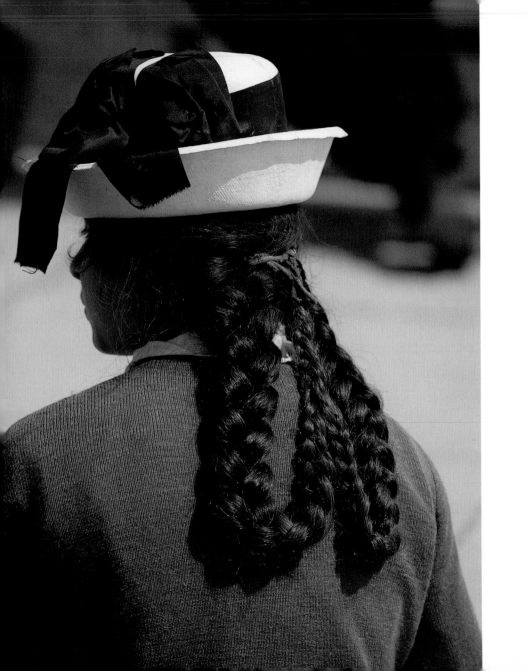

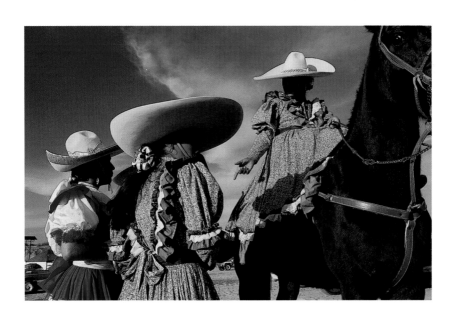

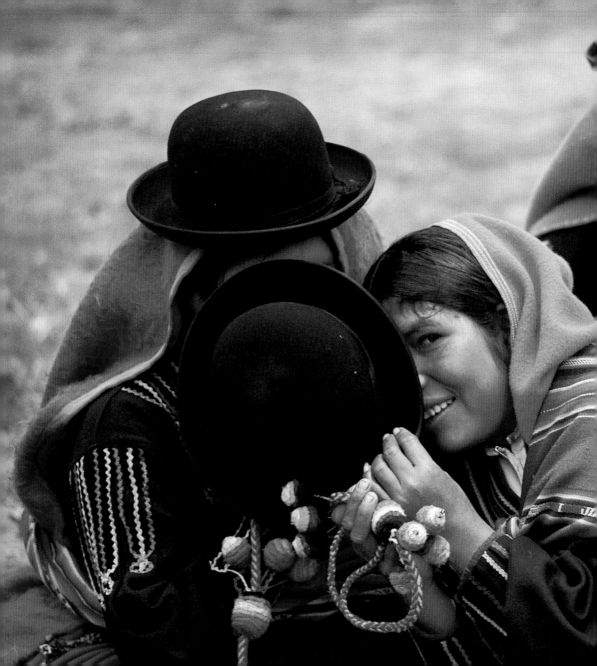

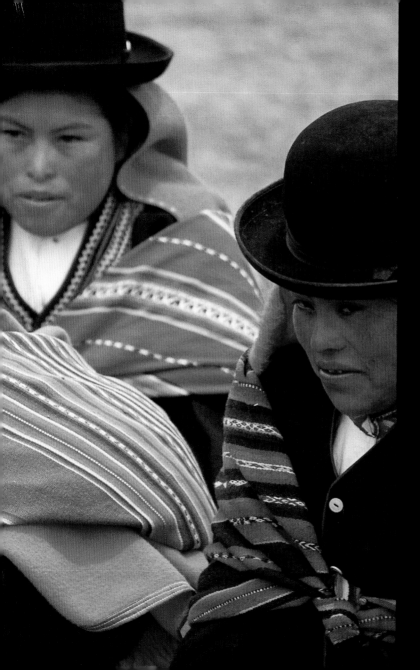

LAKE TITICACA
1971
FLIP SCHULKE

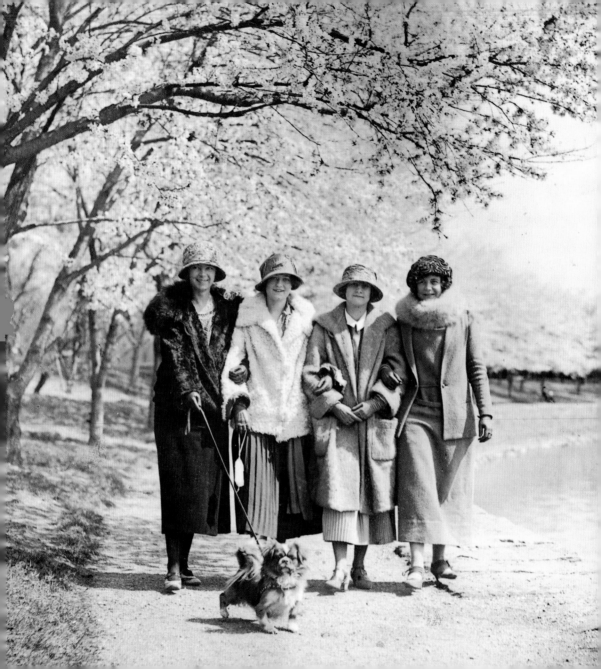

WASHINGTON, D.C.
1923
NATIONAL PHOTO CO.

SUN VALLEY, IDAHO
1994
JOEL SARTORE

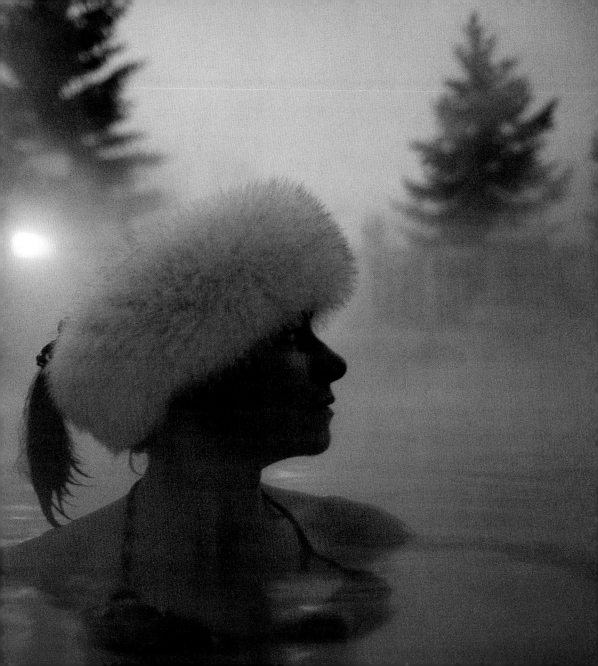

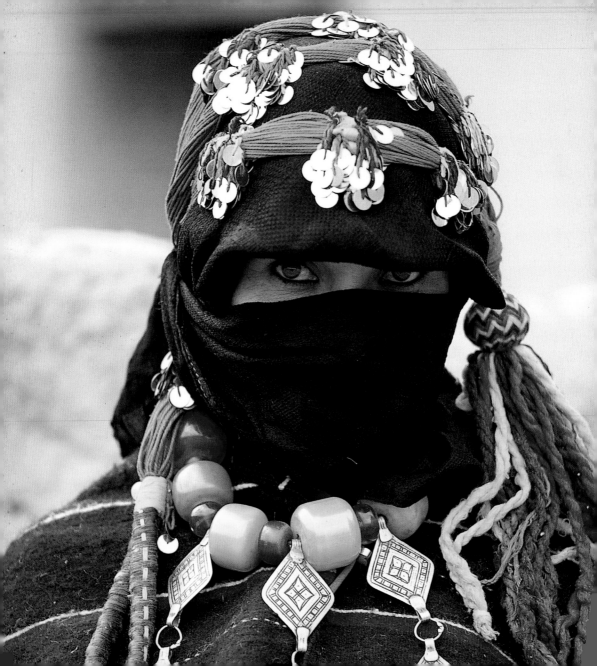

MOROCCO
1980
NIK WHEELER

following pages
SAIGON
1995
KAREN KASMAUSKI

MEXICO
1923
G. GALLARDO

U.S.A.
1920
UNDERWOOD &
UNDERWOOD

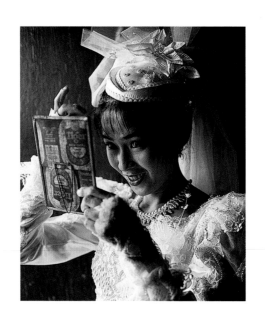

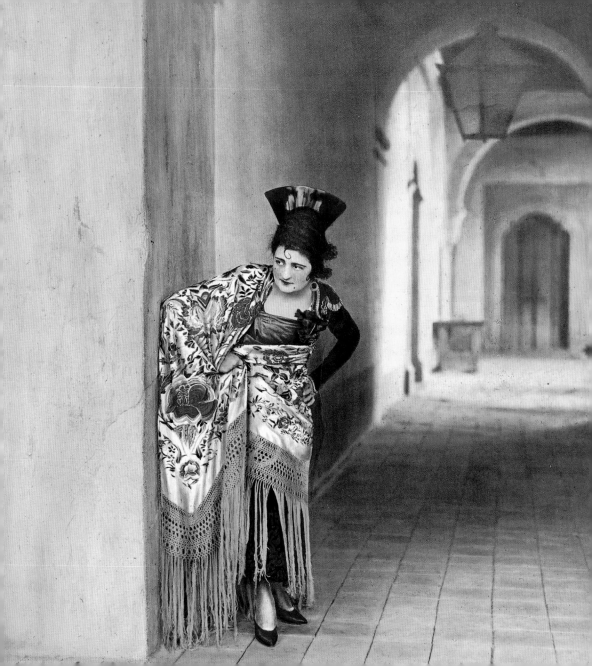

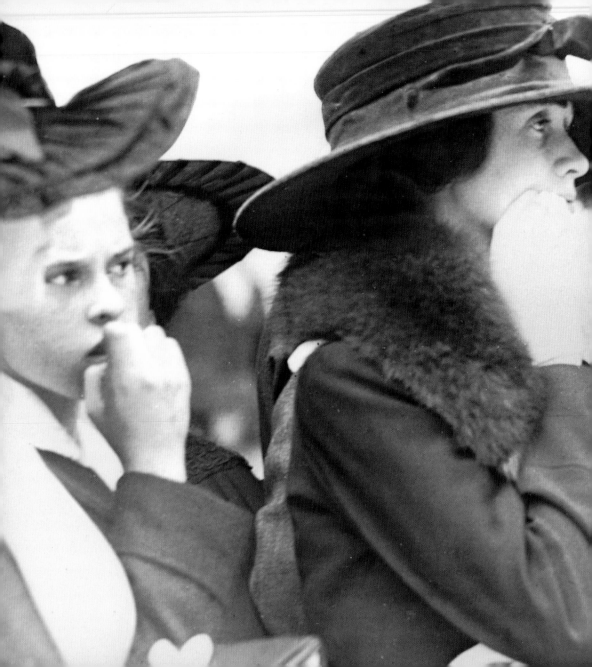

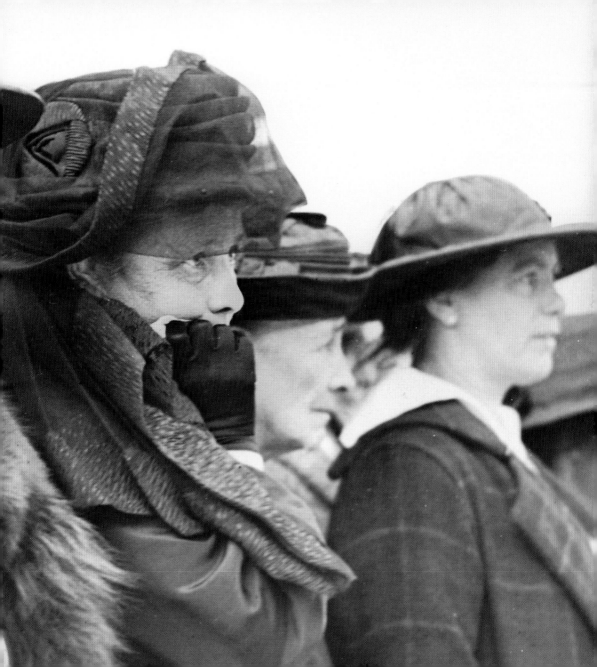

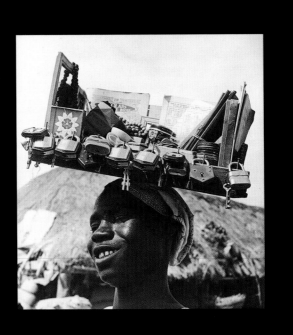

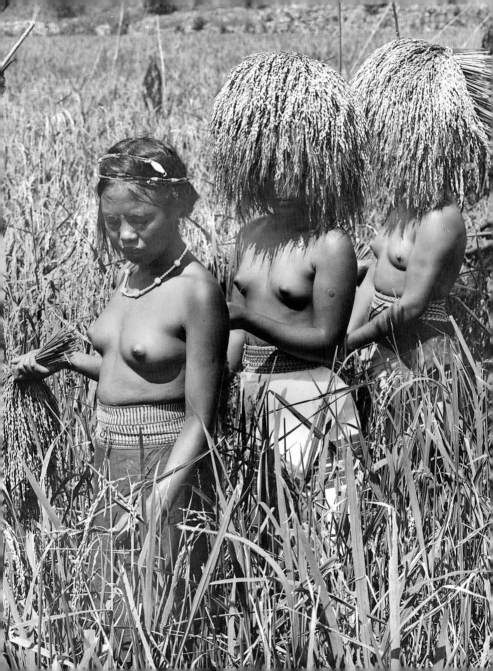

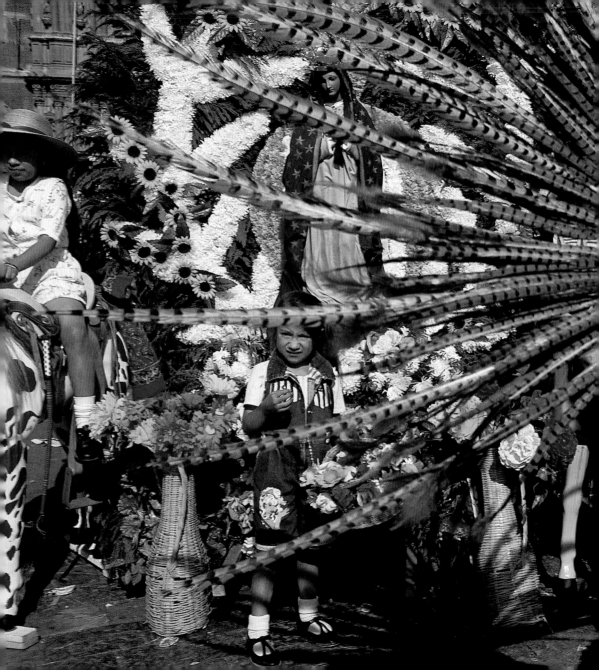

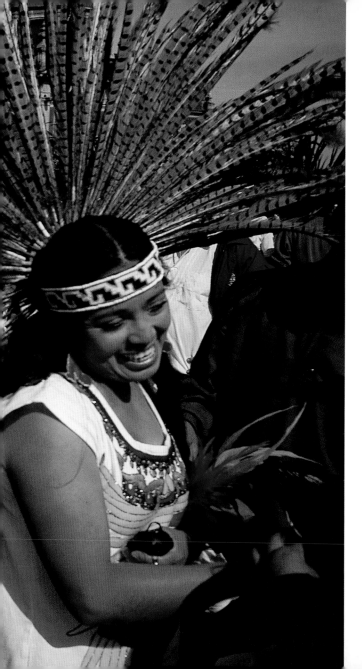

MEXICO
1996
STUART FRANKLIN

preceding pages
KANO, NIGERIA
1956
GEORGE RODGER

LUZON, PHILIPPINE
ISLANDS
1915
CHARLES MARTIN

following pages
PAPEETE, TAHITI,
FRENCH POLYNESIA
1997
JODI COBB

GHENT, BELGIUM
1925
E. SACRE

SEVILLE, SPAIN
1988
BRUNO BARBEY

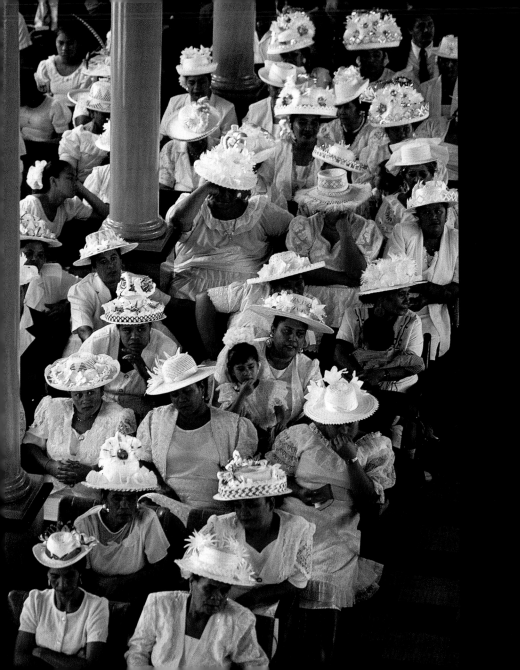

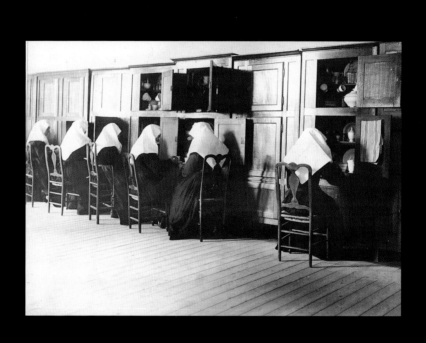

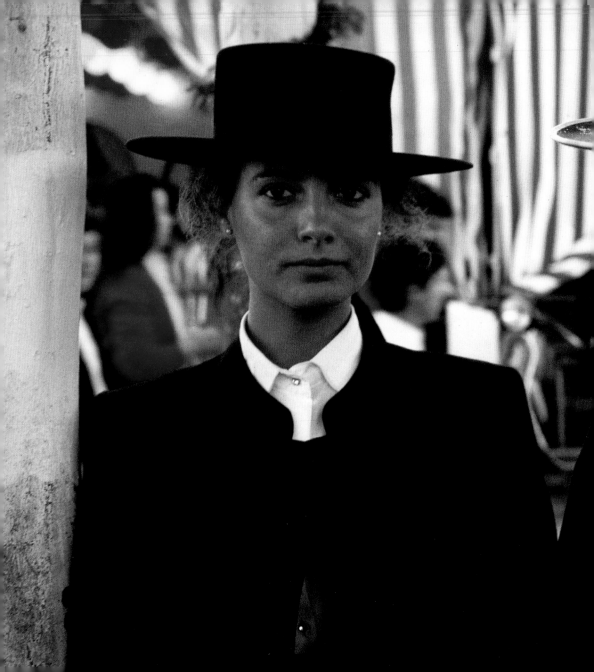

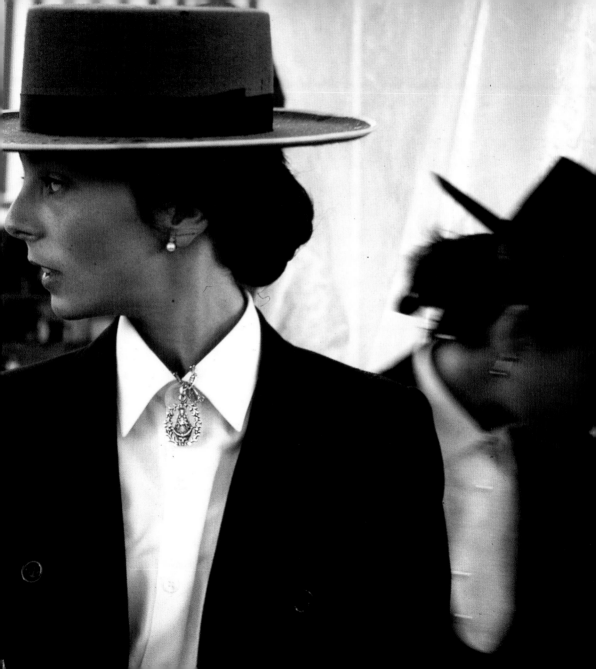

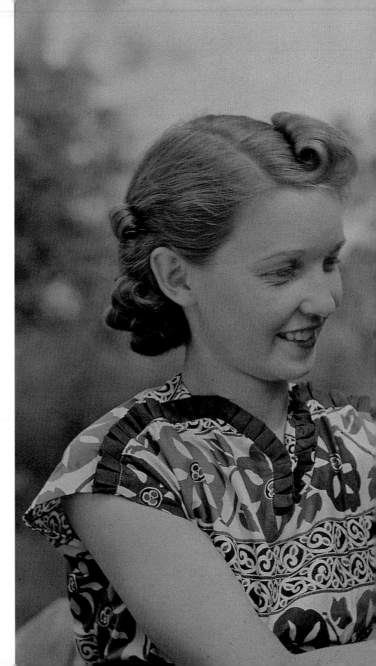

RAYMONDVILLE, TEXAS
1939
B. ANTHONY STEWART

following pages
PARIS, FRANCE
1989
WILLIAM ALBERT ALLARD

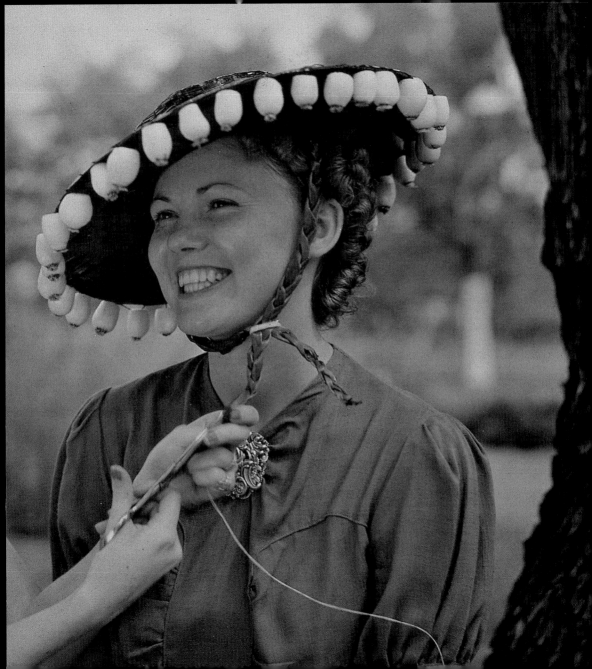

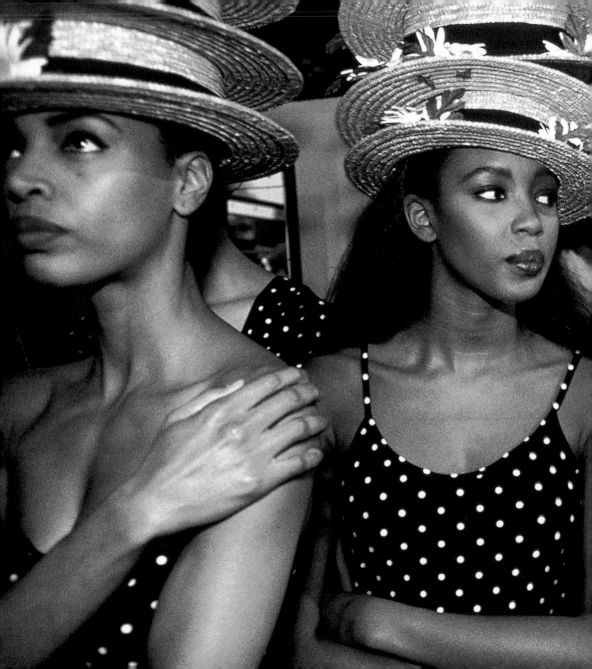

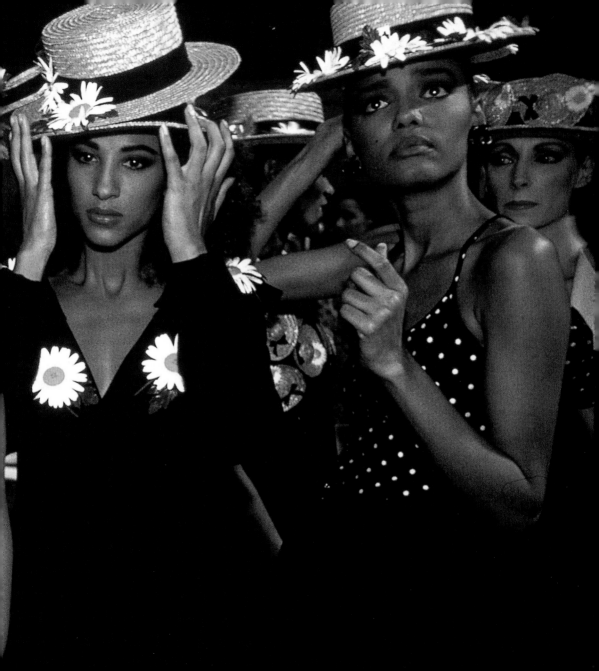

All parents have tied hats on

eir children's heads to keep out the wind or the cold or the sun, but in fact kid's hats are often more than protection from the elements. Their hats can be miniature statements of the culture at large, or a reflection of their own parents' interests (think American baseball), tastes, or aspirations for them. In any case, there's just something irresistible about a kid in a hat. ❧

PISAC, PERU
1996
WILLIAM ALBERT ALLARD

following pages
MIKE-PERCS, HUNGARY
1914
A. W. CUTLER

NEBRASKA
1996
JOEL SARTORE

NEBRASKA
1996
JOEL SARTORE

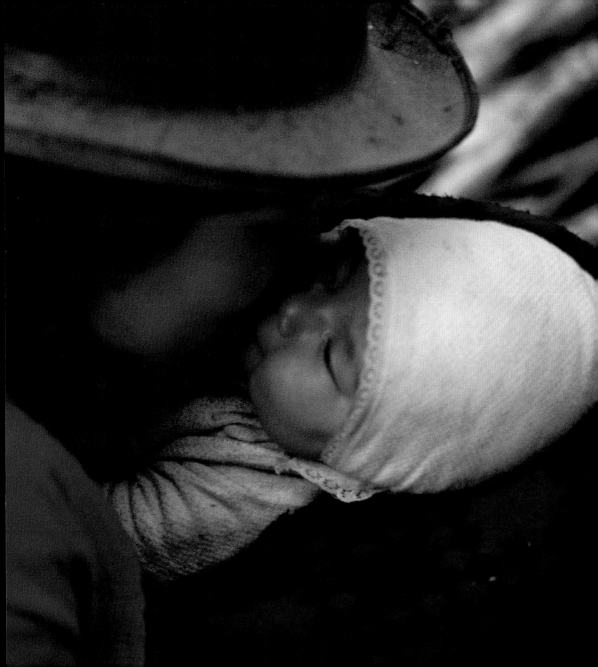

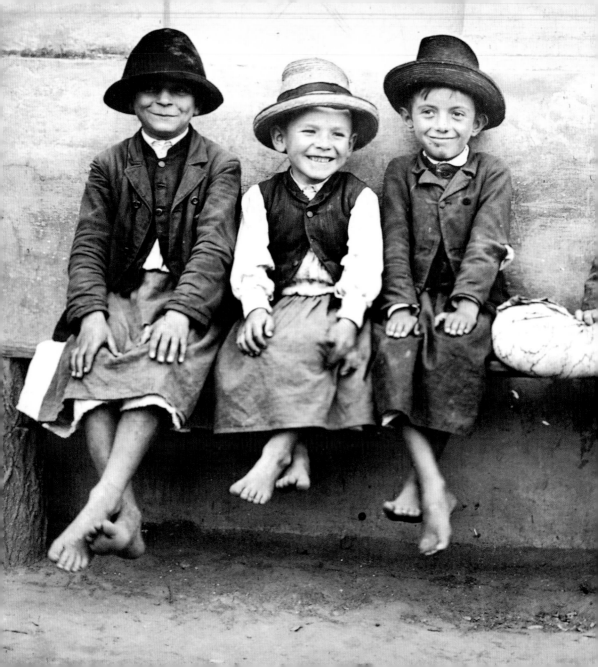

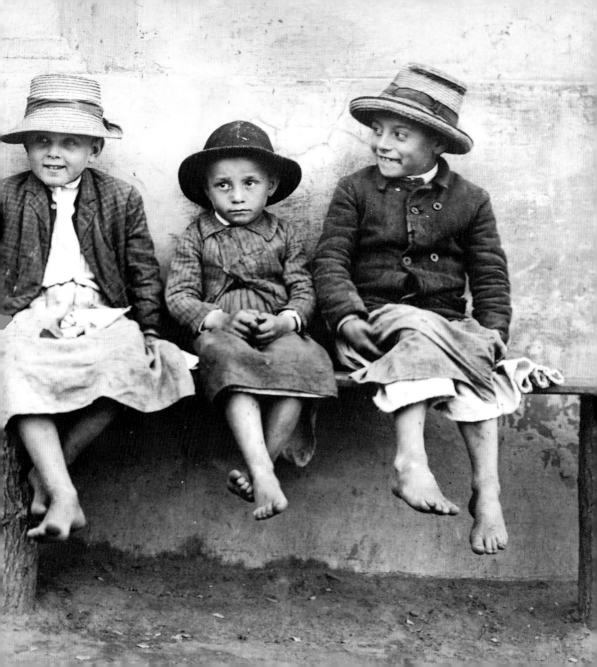

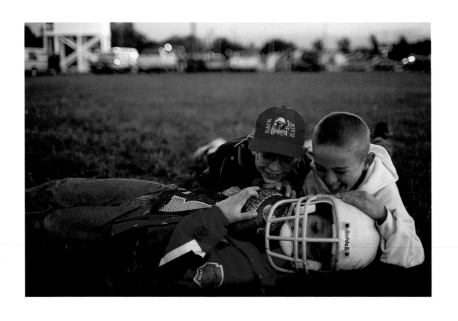

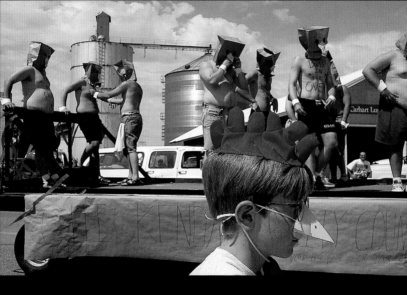

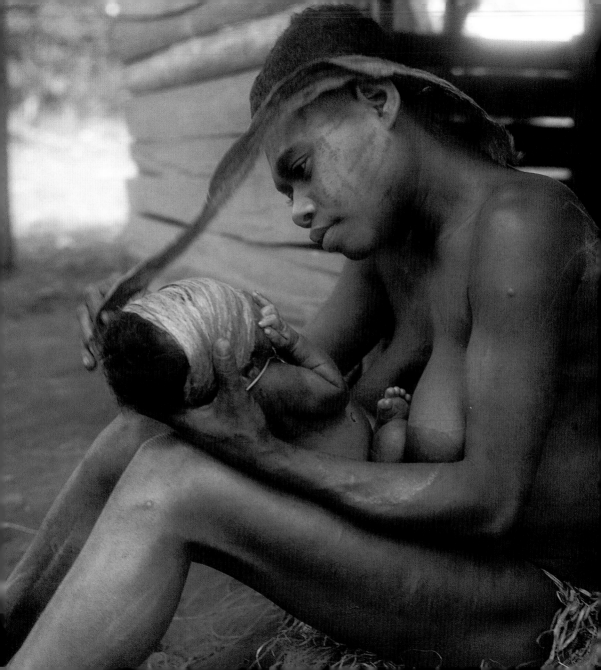

BISMARK ARCHIPELAGO,
NEW GUINEA
1966
ANN CHOWNING

following pages
RUSSIA
1998
GERD LUDWIG

TAHLEQUAH, OKLAHOMA
1990
JOEL SARTORE

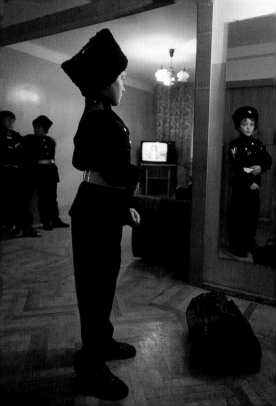

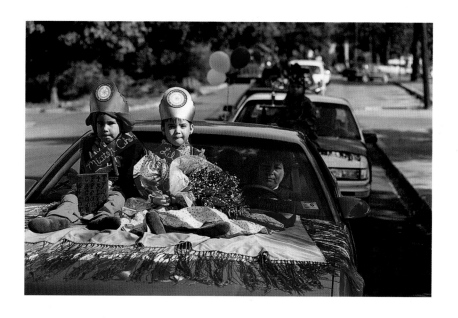

BANGKOK
1917
THEODORE MACKLIN

following pages
CONNECTICUT
1992
JOEL SARTORE

NEWFOUNDLAND
1971
SAM ABELL

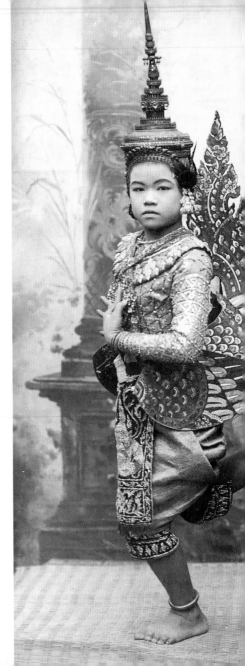

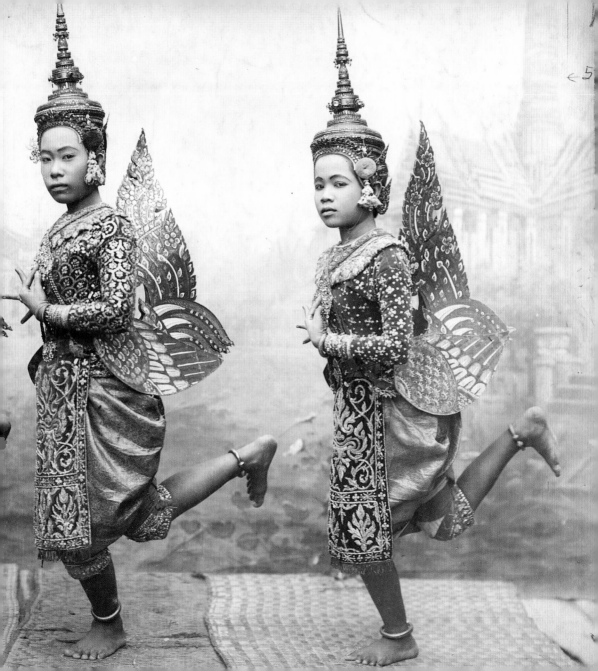

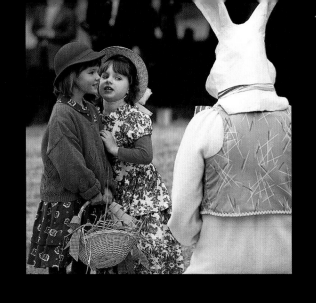

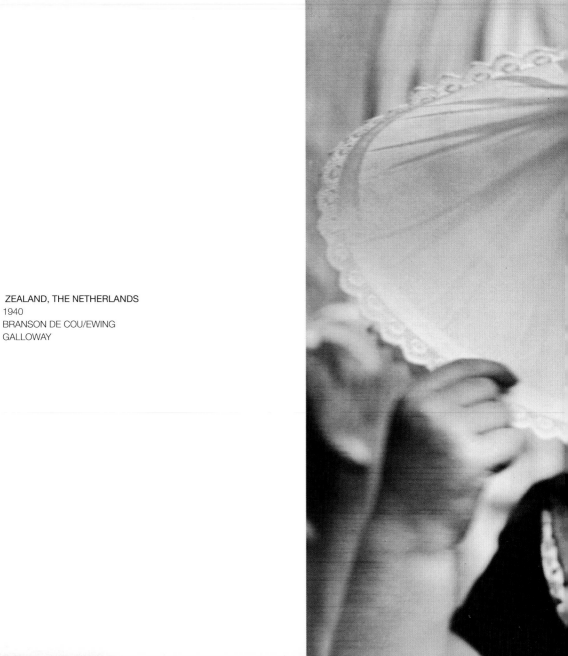

ZEALAND, THE NETHERLANDS
1940
BRANSON DE COU/EWING
GALLOWAY

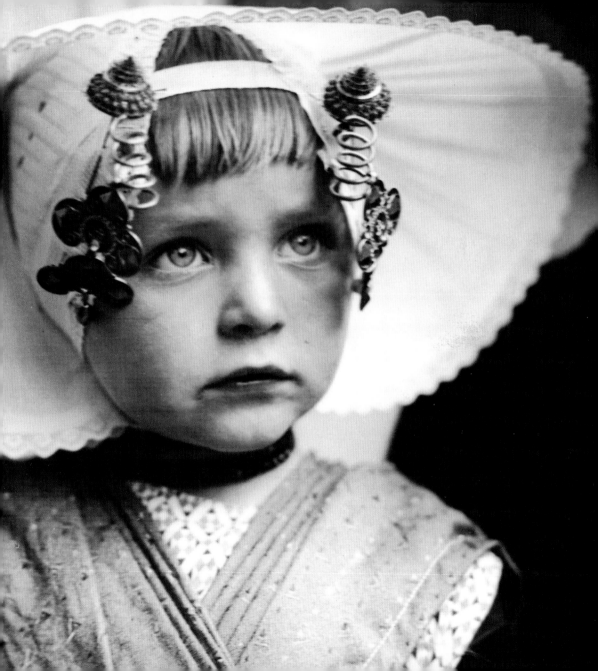

The "Boss of the Plains" has a

ays been a hat with serious attitude. The cowboy's—

or cowgirl's—Stetson is like part of his body: It blocks the sun, keeps

the rain from trickling down his face or down his back, and waves

cattle along. When a photographer inches up on a cowboy, the target

may keep his expression stolid and his feelings to himself, but the angle

and style of his hat always gives him away. ❧

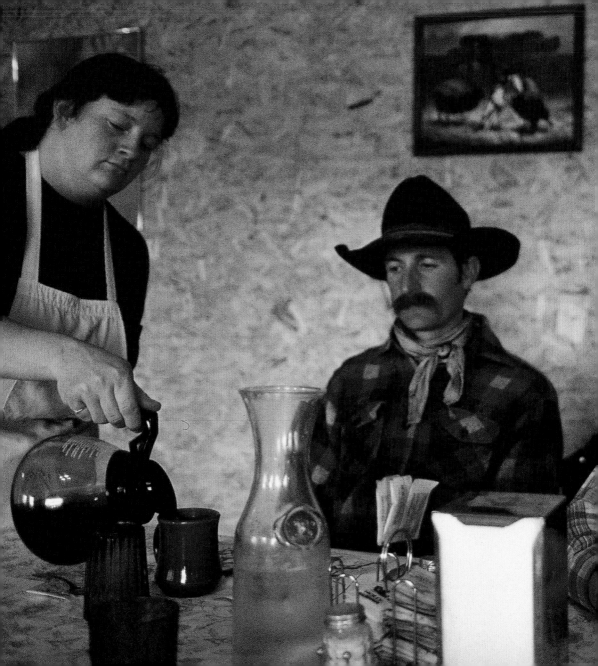

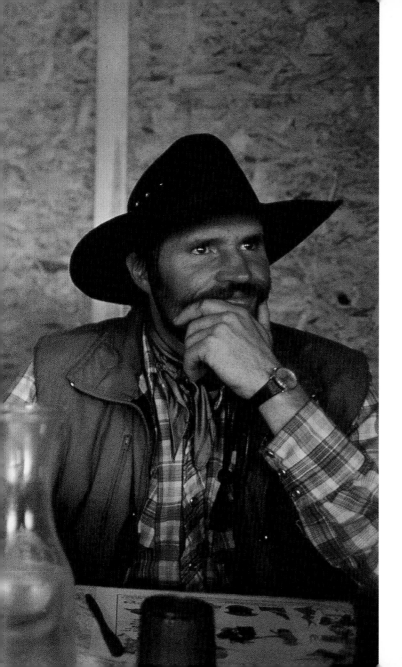

LEADORE, IDAHO
1992
JOEL SARTORE

following pages
AMARILLO, TEXAS
1990
JOEL SARTORE

BORDER OF TEXAS
AND MEXICO
1994
JOEL SARTORE

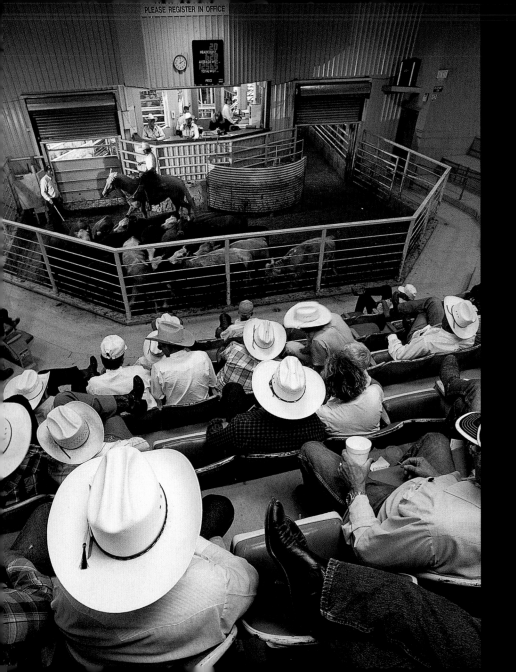

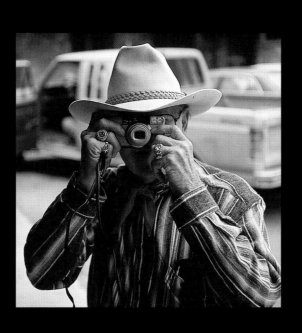

LOCATION UNKNOWN
DATE UNKNOWN
WILLIAM ALBERT ALLARD

following pages
BAJA, CALIFORNIA
1972
MICHAEL E. LONG

COTTONWOOD, CALIFORNIA
1993
JOEL SARTORE

NEBRASKA
1996
JOEL SARTORE

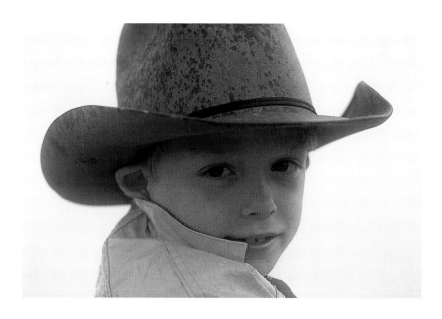

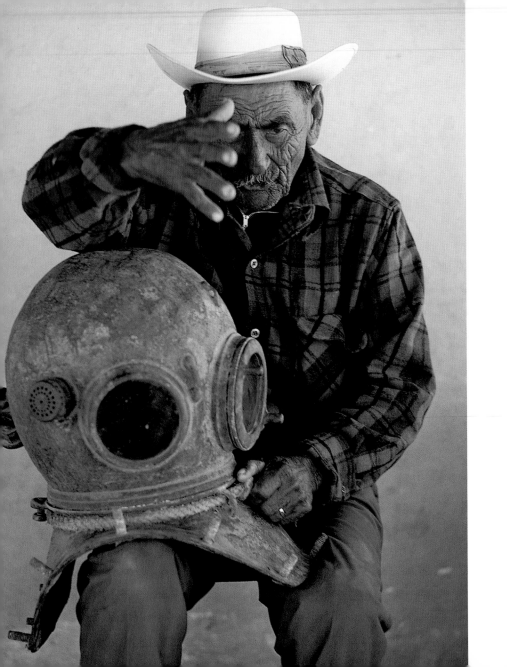

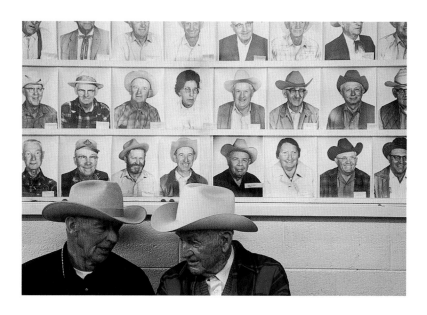

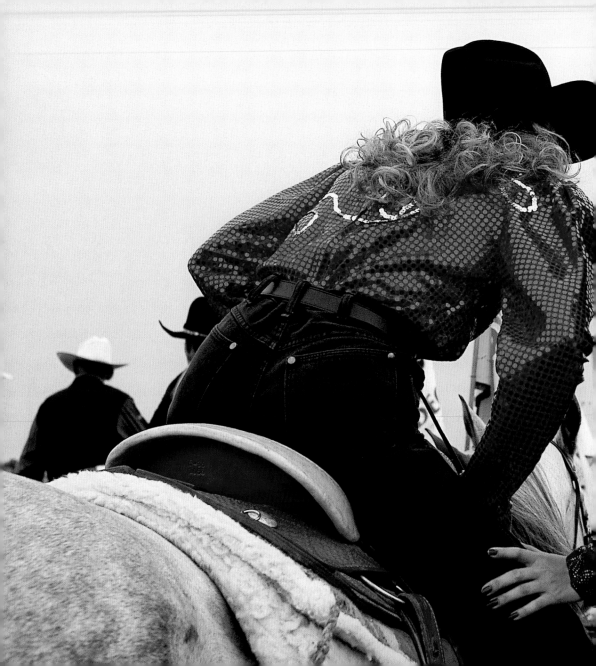

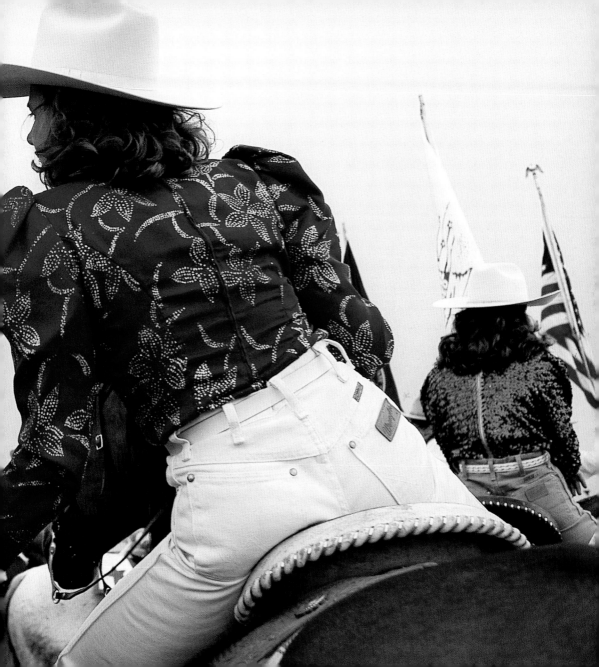

Hats of Western vintage tend to

have a crown and a brim, but the headgear with the longest pedigree is probably the simple head scarf, still favored in parts of the Middle East. Wrap it tightly, and you have a turban—a style that has enjoyed popularity in various forms and fashions over time and across cultures. Turbanesque in its form, the fez, too, has been adopted by fashion, though to the Sufi dervish, it remains a revered part of the sacred dance. ❖

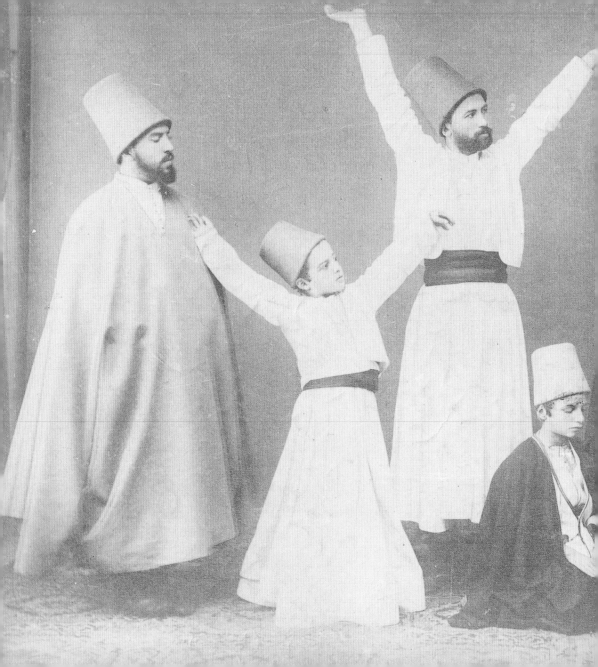

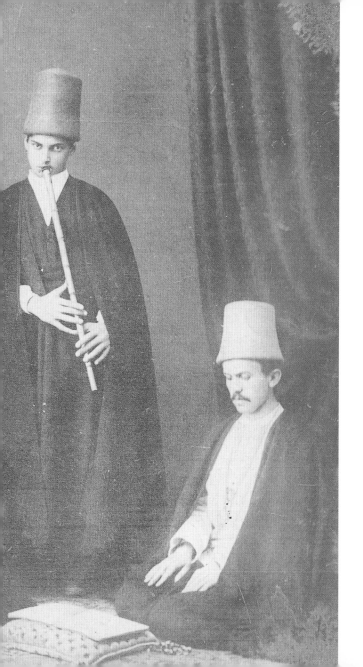

CONSTANTINOPLE
DATE UNKNOWN
PHOTO FROM
ALEX AARONSOHN

INDIA
1917
JOHNSON & HOFFMANN

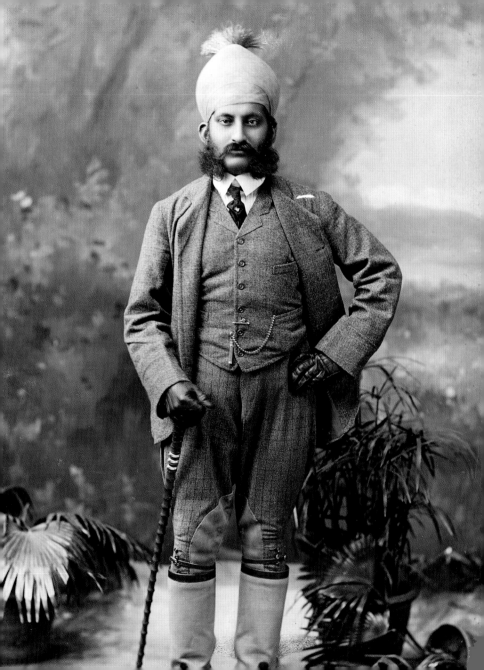

HAVANA, CUBA
DATE UNKNOWN
DAVID ALAN HARVEY

following pages
NIGER
1998
CAROL BECKWITH AND
ANGELA FISHER

HAJJAH, YEMEN
2000
STEVE MCCURRY

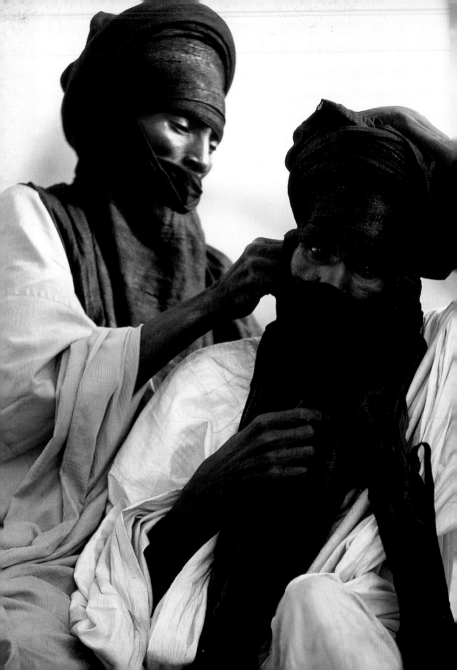

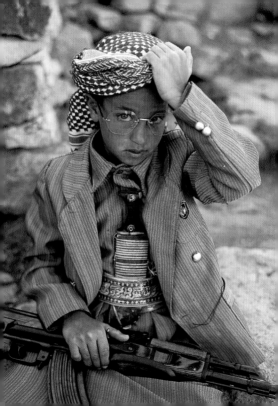

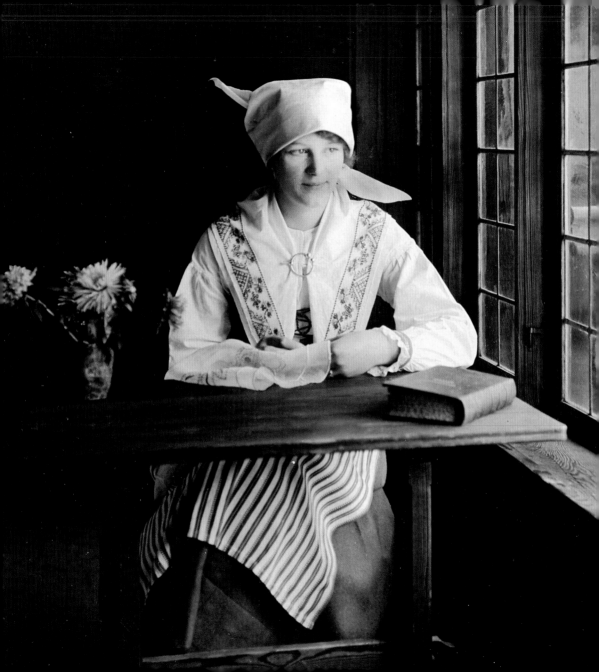

VADSTENA, SWEDEN
1934
DONALD MCLEISH

How is it that couples have a

knack for choosing complementary hats that somehow make them seem like a matching pair? Work hats, warm hats, ceremonial hats, the crowns of royalty, they all seem to show better when they come in male/female pairs. Photographers never miss the appeal of the symmetry—and sometimes the humor—of a couple who have consciously, or unconsciously, announced to the world that they are hatfully coupled. ~❖

MAKAWAO, MAUI
1971
GORDON GAHAN

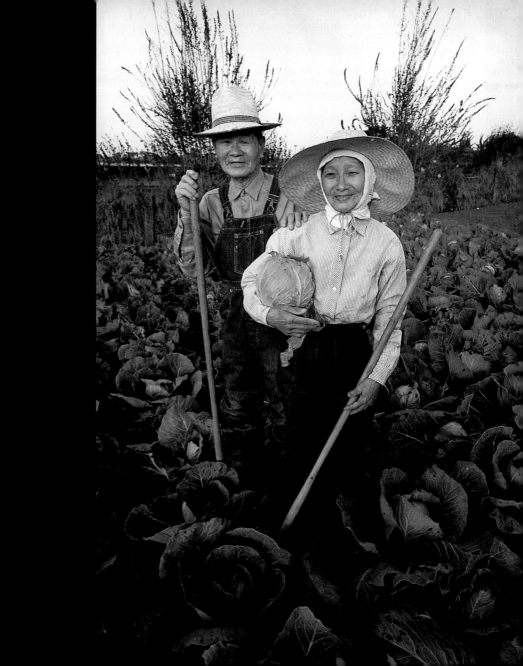

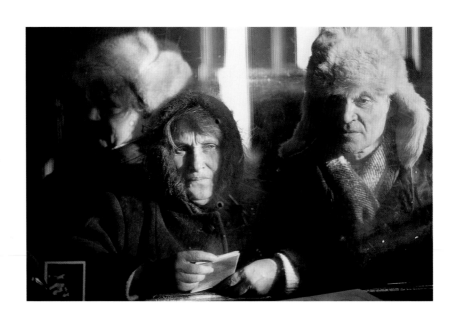

LOCATION UNKNOWN
1997
GERD LUDWIG

CASABLANCA, MOROCCO
1925
WILLARD PRICE

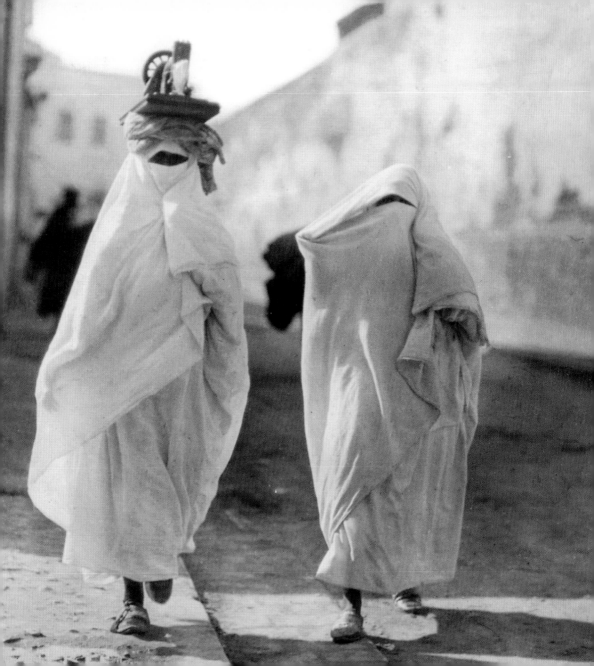

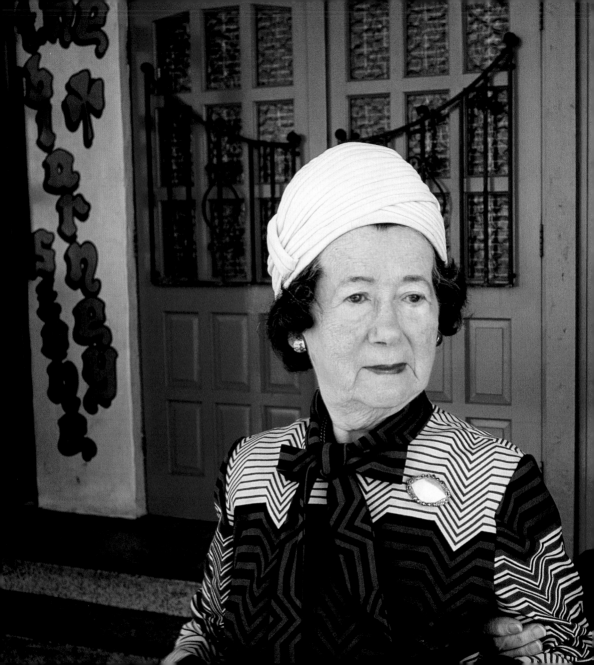

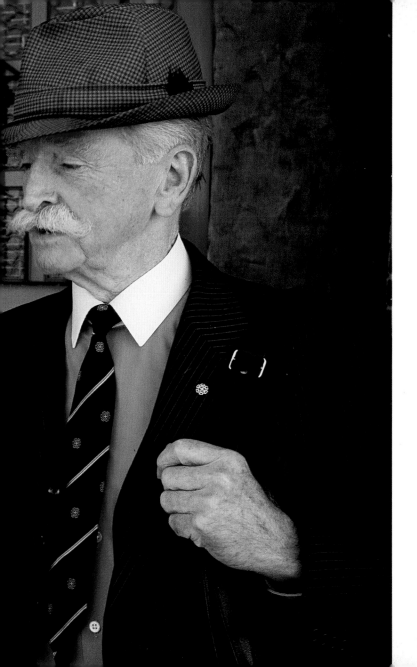

BLACKPOOL, LANCASHIRE,
ENGLAND
1998
TOMASZ TOMASZEWSKI

following pages
NEW YORK CITY, NEW YORK
1918
BROWN BROTHERS

NEW ORLEANS, LOUISIANA
1929
EDWIN L. WISHERD

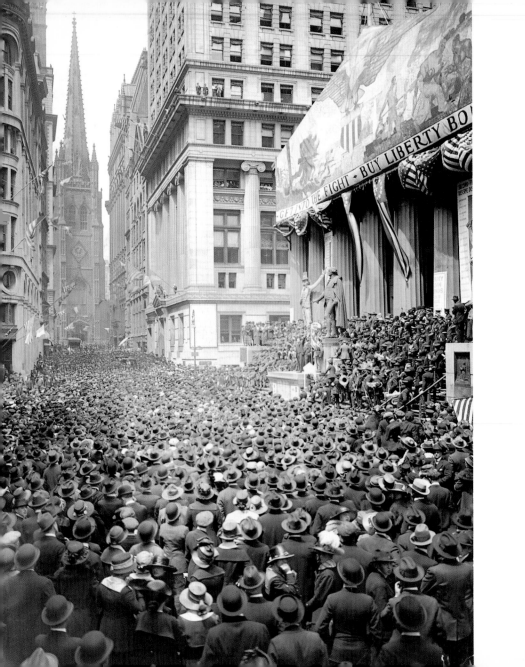

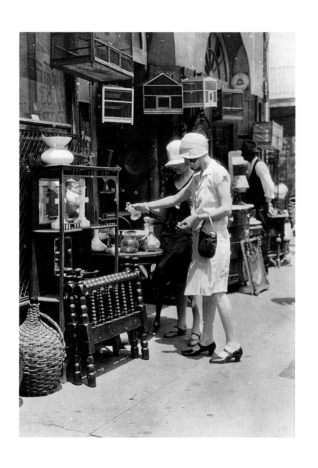

ROUTE 66, ARIZONA
1997
VINCENT J. MUSI

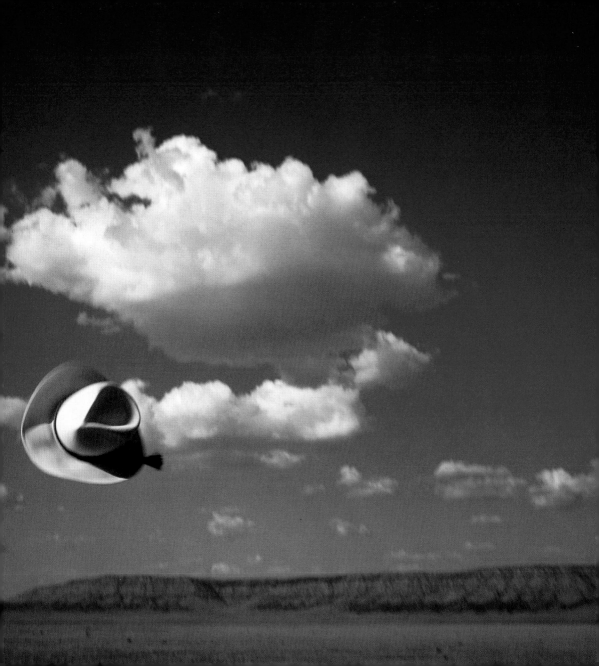

Hats
by K. M. Kostyal

Published by the National Geographic Society

John M. Fahey, Jr., *President and Chief Executive Officer*
Gilbert M. Grosvenor, *Chairman of the Board*
Nina D. Hoffman, *Executive Vice President*

Prepared by the Book Division

Kevin Mulroy, *Vice President and Editor-in-Chief*
Marianne R. Koszorus*, Design Director*
Leah Bendavid-Val, *Editorial Director, Photography Books*

Staff for this Book

Leah Bendavid-Val, *Editor*
Rebecca Lescaze, *Text Editor*
Cinda Rose, *Art Director*
Vickie Donovan, *Illustrations Editor*
Melissa Hunsiker, *Assistant Editor*
Joyce M. Caldwell, *Text Researcher*
R. Gary Colbert, *Production Director*
John T. Dunn, *Technical Director, Manufacturing*
Richard S. Wain, *Production Project Manager*
Sharon K. Berry, *Illustrations Assistant*

We would like to give special thanks to Susan E. Riggs,
Bill Bonner, Brian Drouin, and Patrick Sweigart for their
hard work and generous support for this project.

One of the world's largest nonprofit scientific and edu-
cational organizations, the National Geographic Society
was founded in 1888 "for the increase and diffusion of
geographic knowledge." Fulfilling this mission, the Soci-
ety educates and inspires millions every day through its
magazines, books, television programs, videos, maps
and atlases, research grants, the National Geographic
Bee, teacher workshops, and innovative classroom mate-
rials. The Society is supported through membership dues,
charitable gifts, and income from the sale of its educa-
tional products. This support is vital to National Geo-
graphic's mission to increase global understanding and
promote conservation of our planet through exploration,
research, and education.

For more information,
please call 1-800-NGS LINE (647-5463)

or write to the following address:

1145 17th Street N.W.
Washington, D.C. 20036-4688 U.S.A.

Visit the Society's Web site
at www.nationalgeographic.com.

Front cover and page 3: Mobile, Alabama/1992/Joel Sartore

Additional Credits: pp.15, 82-3 CORBIS; p. 74-5 Library of Congress;
p. 84 Magnum Photos